JOHN
HEDGECOE'S
CAMCORDER
BASICS

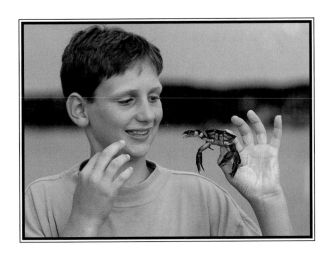

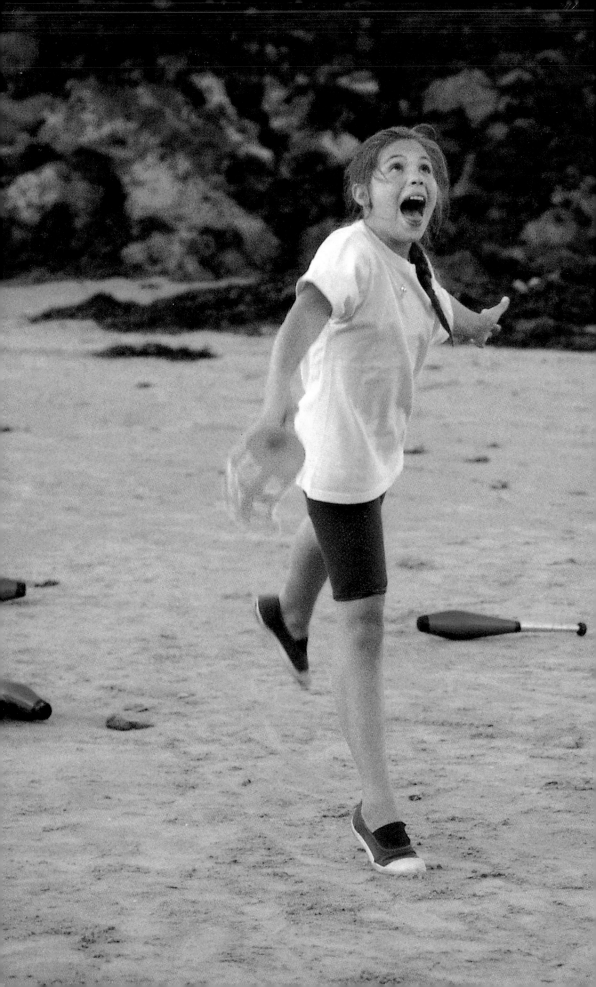

JOHN HEDGECOE'S
CAMCORDER
BASICS

A Quick-and-Easy Guide to Making Better Videos

AMPHOTO
an imprint of Watson-Gupthill Publications/New York

First published in the United States in 1995 by Amphoto, an imprint of
Watson-Guptill Publications, a division of BPI Communications, Inc.,
1515 Broadway, New York, New York 10036

First published in Great Britain in 1995
by Collins & Brown Limited
London House
Great Eastern Wharf
Parkgate Road
London SW11 4NQ

1 3 5 7 9 8 6 4 2

Library of Congress Cataloging-in-Publication Data

Hedgecoe, John.
 [Camcorder basics]
 John Hedgecoe's camcorder basics/ by John Hedgecoe.
 p. cm.
 Includes index.
 ISBN 0-8174-4043-7 (pbk.) : $24.95
 1. Camcorders. 2. Video recordings–Production and direction.
I. Title. II. Title: Camcorder basics
TR882.H44 1995
778.59–dc20 94-40839
 CIP

Conceived, edited and designed by Collins & Brown Limited
Managing Editor: Sarah Hoggett
Associate Writer: Jonathan Hilton
Art Director: Roger Bristow
Designer: Phil Kay

Reproduction by Daylight, Singapore

Printed and bound in Italy by New Interlitho SpA

Contents

Introduction

Most people buy a camcorder for similar reasons they buy a still camera – in order to make a permanent record of their children growing up, friends, important family events such as birthday parties or weddings, vacations, and so on. With a camcorder, however, you have the additional bonus of being able to see your subjects move and hear what they have to say. Only the minority of camcorder users ever expect their tapes to have an appeal that is wider than their circle of family and friends.

The unfortunate thing is that, even though the audience may actually be featured on the tape being watched, most home videos are confused, disjointed, and dull. This is especially sad since, with just a little basic understanding of the medium, every camcorder user is capable of producing tapes that first of all engage and then hold an audience.

Creating good video

For a tape to be entertaining and enjoyable to watch, it needs a coherent structure – a story-line that the audience will recognize. Taking as an example a two-week family vacation, the first thing you need to remember is that a vacation consists of a series of episodes; it is not a single, continuous event.

The first episode could be the family packing the car with suitcases and toys and, to set the mood, you will have a soundtrack of everybody's excited chatter about what they hope the vacation will be like. You could then cut to a shot taken through the back window of the car as you drive away, showing your house growing smaller and smaller. In all, this should probably not take up more than a minute or two of screen time.

To indicate a change of location, the next episode could start with a wide establishing shot of the out-of-town countryside where you have stopped for lunch. If possible, cut to a signpost telling the audience where you are. Following this, you could include footage of some of the more entertaining aspects of the lunch, concluding with a shot of the car pulling away to resume the journey. Again, no more than a minute or two or screen time should be taken up with this episode.

To ease into the next sequence – arriving at the hotel – shoot some footage from the car as you pass through towns or attractive stretches of countryside en route. Try to include place names if possible. At most, a minute of this type of material brings you to your destination. Start again with an establishing shot, moving into detailed close-ups if the architecture, gardens, or grounds warrant it.

The next obvious scene could be the reception area – checking in – or you could cut straight to your hotel room, showing the interior as well as the view from the balcony. Less than a minute of screen time should be devoted to this. Even at this point, you can see that from leaving home to arriving at your

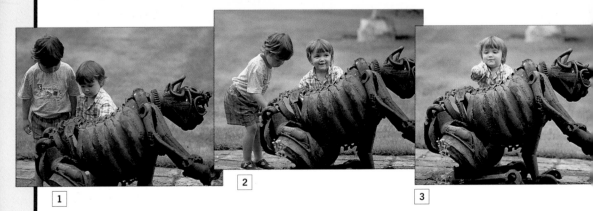

1

2

3

hotel has taken up only about 5 to 7 minutes of screen time. How many vacation tapes have you sat through, in which the car is only half loaded after the first 10 minutes?

Following this, you will want your tape to show short episodes of life in the hotel – the restaurant, for example, the kids, eating by the pool, people you meet, members of the staff who are friendly and helpful. Other episodes would then feature your activities – trips to spots of local historical interest, beach barbecues, the children playing, shots of local color and atmosphere, or whatever it is you and your family do on vacation.

Within this book, you will find numerous examples of how you can tackle each one of these activities, as well as many other types of subject, with suggestions on how to shoot them; exposure and sound considerations; the use of different shot framings and angles; and, often, suggested running times. Even if the examples don't exactly mirror your circumstances, you should be able to adapt the information quite easily.

Always bear in mind the attention span of your tape's intended audience. The two-week vacation discussed here could be condensed into a 30-minute tape – one you will enjoy watching time and time again.

How to use this book

The camcorder is probably one of the most sophisticated pieces of electronics you are likely to have in your home, so making the right purchasing decision is paramount. The first chapter of this book, therefore, assumes you know nothing about camcorders and explains the different formats, their advantages and disadvantages, and demystifies much of the jargon associated with their various features. The second chapter is devoted to the nuts and bolts of how to shoot technically good videos, starting with holding the camcorder properly; how both the machine and videotape react to different types of lighting; shot composition; framing and focusing; recording sound; and how to achieve such professional-looking camcorder movements as pans and tilts.

The final five chapters of the book are broken down into specific subject areas. These cover children, weddings, vacations, action, and the natural world, and they represent the types of subjects camcorder users seem most interested in. In each, you will see examples of how specific frames were taken, the problems that had to be contended with, and how they were overcome. Like all visual media, the video image needs to be framed, composed, and exposed to show the subject to best advantage, and throughout these pages you will find imagery that, hopefully, will inspire you to learn more about the potential your camcorder has to offer.

7

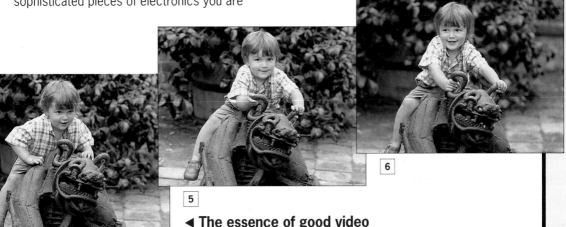

`5` `6`

◄ The essence of good video

Any subject makes a potentially good video subject – especially children. To be entertained, your audience needs to see thoughtfully framed and well-composed images, with good use of different shot sizes and backgrounds.

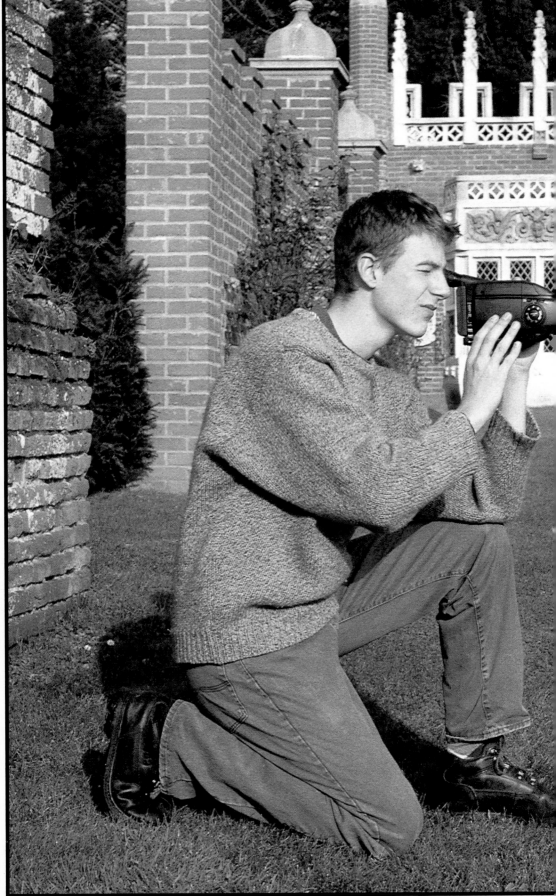

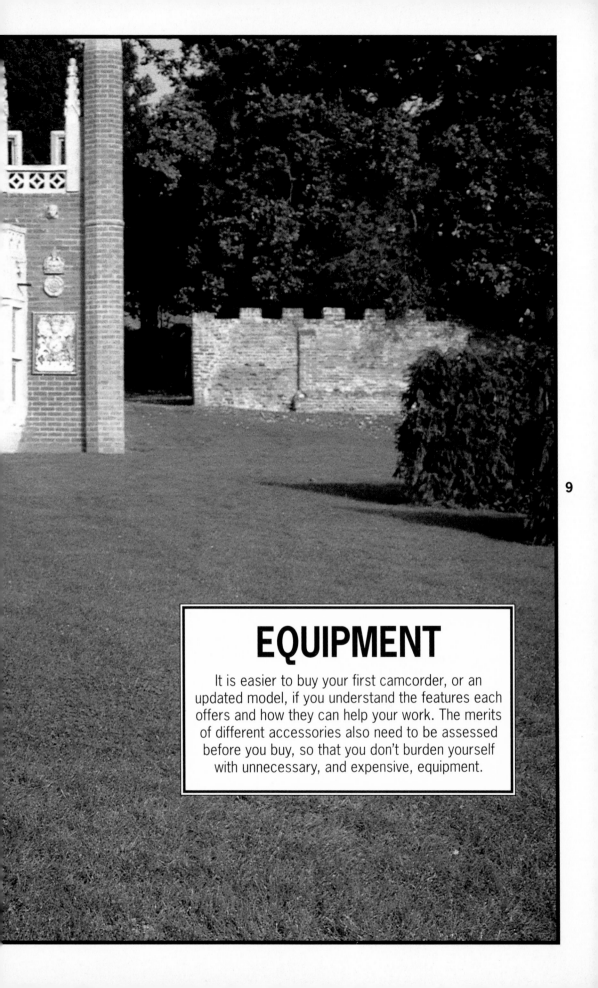

EQUIPMENT

It is easier to buy your first camcorder, or an updated model, if you understand the features each offers and how they can help your work. The merits of different accessories also need to be assessed before you buy, so that you don't burden yourself with unnecessary, and expensive, equipment.

Choosing a camcorder

Competition between manufacturers has led to the development of a range of different, largely incompatible, formats: full-size VHS, VHS-C, and 8mm.

The original camcorder format is VHS. Although large and heavy, VHS camcorders use the same cassettes as domestic video cassette recorders (VCRs), making playback effortless. VHS-C is a development of this original format – the 'C' stands for compact. These machines are smaller and lighter, and their cassettes fit into an adaptor for playback in a VCR. The most popular format today is 8mm. Tapes are, however, incompatible with most VCRs and so the camcorder is plugged directly into the television set for playback.

As well as these basic formats, each is available in an enhanced form – S-VHS, S-VHS-C (the 'S' stands for super), and Hi8. These 'high-band' machines offer a marked improvement in both picture and sound quality, but the full benefit is realized only if playback is via a high-band VCR.

Tinycams

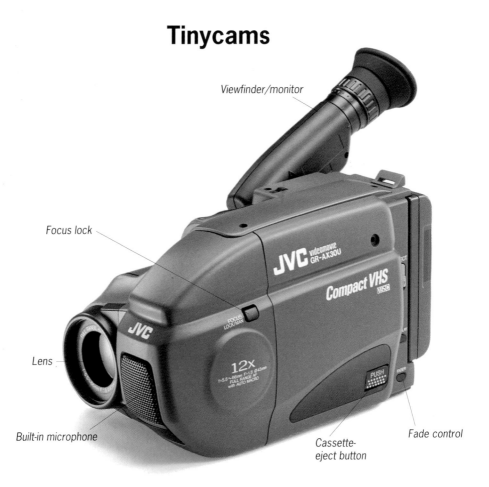

Viewfinder/monitor

Focus lock

Lens

Built-in microphone

Cassette-eject button

Fade control

▲ Small and full-featured

Because the size of the cassette is one of the principal factors determining the camcorder's size, those that use very small cassettes can be made palm-sized and very light while still retaining a full range of features. These 'tinycams' are exceptionally compact, but they do not represent a format in their own right. Tinycams are available in VHS-C, S-VHS-C, 8mm, and Hi8 formats.

Full-size VHS

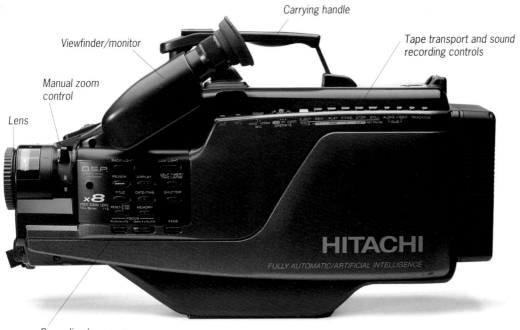

Carrying handle

Viewfinder/monitor

Tape transport and sound
recording controls

Manual zoom
control

Lens

Recording/exposure
control panel

11

▲ Full-size VHS camcorder

Although VHS has been long regarded as the world standard for home video, full-size VHS camcorders are declining in popularity. The size of these machines inevitably draws attention when they are in use, and because of their weight and size it is hard to use them casually as point-and-shoot machines when a spontaneous taping opportunity occurs. In their favor, however, is that since they rest on the operator's shoulder, images tend to be steady and free from the jitter common with smaller machines.

Features

● Because of their size and weight, VHS camcorders – both VHS and S-VHS formats – are designed to be shoulder-mounted.

● Low-band VHS camcorders record on exactly the same tapes used in domestic VCR machines, allowing the convenience of playback through any VHS VCR.

● High-band S-VHS camcorders require special high-performance blank tapes. Unfortunately, these cannot be played back on an ordinary VCR, so the principal feature of the format – convenience – is lost. Expensive S-VHS VCRs and televisions are available. These have dedicated S-terminals connected by S-leads.

● The picture quality of VHS is comparable to that of VHS-C and 8mm video. Unless you buy a hi-fi model, however, sound quality does not match that of 8mm.

Super VHS (S-VHS)

The enhanced high-band S-VHS format was developed to produce improved picture and sound recording as compared with standard VHS. In order to obtain the full benefits of S-VHS, however, you need to record on specially enhanced blank tapes. These look like standard VHS tapes but they will not play back via a domestic VCR – a dedicated S-VHS VCR is needed instead. If you choose to use standard VHS tapes in an S-VHS camcorder, then all the potential improvements in sound and picture quality will be lost, since the machine will be recording basically a low-band signal. Like standard VHS camcorders, S-VHS camcorders are heavy and bulky.

VHS-C

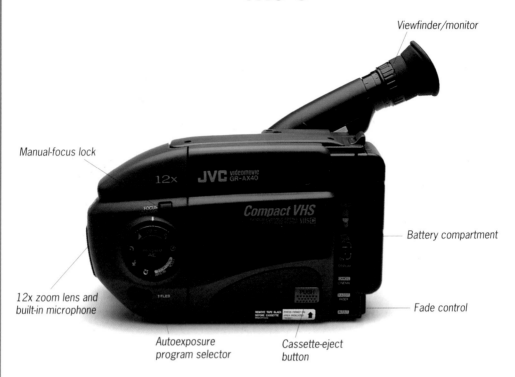

Viewfinder/monitor

Manual-focus lock

Battery compartment

12x zoom lens and built-in microphone

Fade control

Autoexposure program selector

Cassette-eject button

12

▲ VHS-C camcorder

The VHS-C format of camcorders uses exactly the same formulation of videotape as a full-size VHS machine but it is packaged in a more compact cassette. As a result, VHS-C camcorders are considerably smaller and lighter than their full-size equivalents and, although some recording time has been sacrificed, VHS-C cassettes can still be played back via most domestic VCRs (see Features below).

Features

- C (compact) VHS camcorders have the convenience of being smaller and lighter than full-size VHS machines.

- The smaller cassette used in a VHS-C or an S-VHS-C camcorder can be played back via a domestic VCR by means of an adaptor.

- The tapes produced in a VHS-C camcorder are completely compatible with the overwhelming majority of domestic VCRs.

- The tapes produced in an S-VHS-C camcorder have to be played back through an S-VHS VCR using special S-leads to connect the VCR and television.

- If sound quality is important to you, it is worth considering the purchase of a stereo version of a VHS-C or S-VHS-C camcorder. These camcorders use a different method of recording, which reduces tape distortion.

S-VHS-C (Super VHS-C)

The enhanced high-band S-VHS-C format has a sufficiently high picture-recording specification to make it worth considering as an alternative to the popular 8mm format. However, this format has not proved as popular as 8mm, with the consequence that there are fewer to choose from and so prices tend to be higher. You can use standard VHS-C-formulated cassettes in an S-VHS or S-VHS-C camcorder, but you then lose the benefits of the enhanced picture and sound quality. To get the maximum benefit from a high-band machine, you must use the higher-specification tapes and play back and/or edit your tapes in a dedicated S-VHS VCR.

8mm

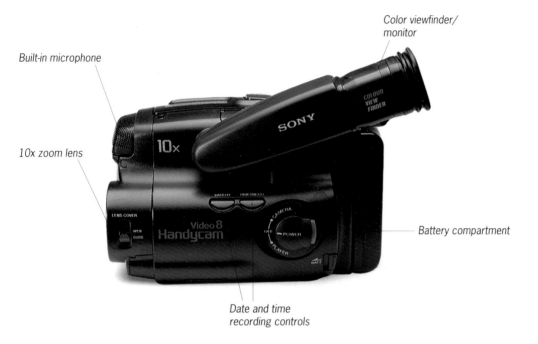

Color viewfinder/
monitor

Built-in microphone

10x zoom lens

Battery compartment

Date and time
recording controls

13

▲ 8mm camcorder

This format is also sometimes known as Video 8. In
terms of picture quality, it is at least as good as
the other low-band formats – VHS and VHS-C – and
some people argue that 8mm is superior. It is in
terms of sound recording that 8mm has the lead
over the VHS formats but, because of the way the
sound signal is recorded, it cannot be replaced
afterwards as part of the editing process.

Features

● Both 8mm and Hi8 have longer tape running
times than the high- and low-band compact
versions of VHS.

● Both 8mm and Hi8 are incompatible with
VHS VCRs. Unless you have a special 8mm
playback machine, you can play back your
tapes only by connecting the camcorder dir-
ectly to your television, using dedicated leads.

● Hi8 camcorders can be used to record in
both high-band and low-band modes,
although a low-band 8mm machine cannot
play back a high-band recording.

● 8mm and Hi8 camcorders offer superior
sound recording compared with mono VHS-C
and VHS camcorders, since the soundtrack
is part of the video signal.

● The sound and pictures are locked together
on 8mm camcorders, so you cannot re-
record the sound as on mono VHS machines.

Hi8

At present, Hi8 – the high-band equivalent of
8mm video – offers the best specification of
sound and pictures in an amateur camcorder.
Although not truly up to the quality of profes-
sional broadcast machines, the quality of Hi8 is
sufficiently good for it to be used by some
professional videographers and journalists
when a compact, lightweight machine is
needed on location. Like its low-band, 8mm
equivalent, Hi8 is totally incompatible with VHS,
which means that Hi8 tapes cannot be played
back in a VHS VCR. Instead, the camcorder
acts as the VCR when connected by the
appropriate cables to the television and when
the camera/VCR camcorder control is set to
VCR. There are at present a a limited number
of 8mm VCRs on the market. These are
competitively priced, compared with better-
quality VHS models, and there is at least one
consumer-grade Hi8 editing VCR as well.

Screencams

This recent addition to the extensive range of camcorder body styles and formats is more than simply a gimmick. Instead of the tiny viewfinder image produced by traditional camcorders, which requires that the machine be held at eye level while in use, the screencam uses a full-color liquid-crystal display (LCD). The screen is sufficiently large to act as a convenient playback monitor as well. The lens assembly rotates to suit the shooting angle you feel most comfortable with, and most lens assemblies will even point backward so that you can shoot yourself. Mono and stereo models are available.

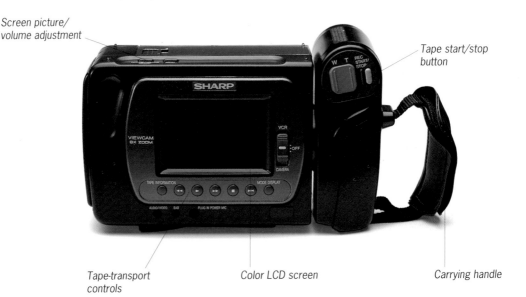

Screen picture/volume adjustment

Tape start/stop button

Tape-transport controls

Color LCD screen

Carrying handle

▲ User-friendly 8mm format

Although radically different in appearance from traditional camcorders, this new design is not a distinct format. Using 8mm technology, it offers the videographer freedom from having to squint into an often uncomfortable eyepiece by replacing or augmenting the viewfinder monitor with a 3- or 4-in (7.5- or 10-cm) LCD, which allows the recorder to be used even when held at waist level.

Comparison of camcorder formats

	Full-size VHS	Super VHS	VHS-C	S-VHS-C	8mm	Hi8
Cassette size (hxwxd) (in/cm)	7.4x1x4 18.8x2.5x10.5	7.4x1x4 18.8x2.5x10.5	3.6x0.9x2.4 9.2x2.3x6.0	3.6x0.9x2.4 9.2x2.3x6.0	3.7x0.6x2.5 9.5x1.5x6.2	3.7x0.6x2.5 9.5x1.5x6.2
*Tape running time	300 minutes	240 minutes	60 minutes	60 minutes	120 minutes	70 minutes
†Picture quality	240 lines	400 lines	240 lines	400 lines	240 lines	400 lines
‡Sound quality	AM radio quality	AM radio quality	AM radio quality	AM radio quality	FM radio quality	FM radio quality
Home VHS VCR playback	Direct	Direct on S-VHS VCR	Requires adaptor	Requires adaptor and S-VHS VCR	Incompatible	Incompatible

* Maximum running time, standard play. † 240 lines = sub-broadcast standard;
400 lines = broadcast standard. ‡ VHS camcorders marked 'hi-fi' offer FM radio quality.

Tape vs. film

The convenience of video tape has all but killed home movie film, at least as an amateur medium. With tape, a charge-coupled device (CCD) in the camcorder takes the image transmitted by the lens and converts it into a series of electrical impulses that are re-corded on the videotape. On playback, these impulses are converted back into visual signals that can be displayed on a video monitor or tele-vision without any intervening processing stage. A single cassette can also be recorded on many times before showing any signs of deterioration. Be-fore film can be projected, the latent, invisible image produced at the time of filming has to be chemically revealed by running it through a sequence of chemical baths. However, editing home movie film is easier than editing video-tape because all you need do is hold the film up to the light to see exactly where you need to cut.

Full-size VHS

VHS-C *8mm*

▲ Tape formats
These cassettes show the comparative sizes of the three video formats – full-size VHS, compact VHS, and 8mm.

15

Batteries and charging batteries

Nearly all camcorders run on rechargeable nickel cadmium (NiCd) batteries, although the voltage may vary between 6v, 9.6v, and 12v. The average amount of shooting a fully charged battery pack will give you is only about 30 minutes, so make sure that before going out on any shoot the battery pack in the camcorder is fully charged and that you have a spare battery pack in your gadget bag. Heavy-duty battery packs are also available and these are capable of producing enough power for about an hour or more of taping. However, bear in mind that all the camcorder's functions run off the battery, so the more zooming, rewinding, and

reviewing of material you do, the faster the battery will run down. Before recharging NiCd batteries, carefully read the instructions that come with the recharger. From these, you will see that the bat-tery can accept a full charge only if you first dissipate almost all of the remaining power in the battery cells. Otherwise, over time, the battery will 'learn' not to accept a full charge and 'remember' to accept less and less, so providing shorter and shorter running times. Most rechargers include a discharge function for this purpose, or you can simply leave the camcorder on until the battery completely cuts out.

◄ Battery packs
Not all camcorders run off the same voltage, so make sure you buy the right type of replacement battery for your camcorder. About 30 minutes of running time is average for a fully charged battery pack, although heavy-duty packs are available that give an hour or more of continuous power.

Built-in or external microphones

All modern camcorders have a built-in microphone, the quality of which can vary between excellent and extremely poor. The usual position of the microphone above the zoom lens, however, often causes problems, since the sound of the motor shifting the lens in and out is likely to be recorded whenever it operates. To overcome this, many modern camcorders have a socket into which an external microphone can be plugged. To minimize extraneous noise, an extension cable should be fitted and the microphone placed as close as possible to the desired sound source.

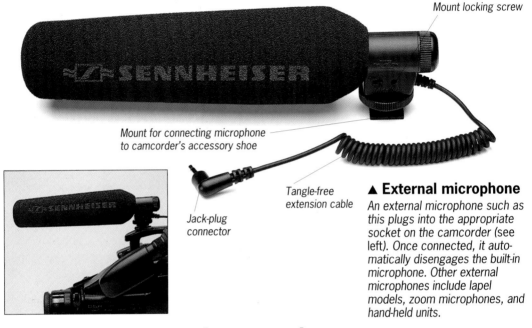

Mount locking screw

Mount for connecting microphone to camcorder's accessory shoe

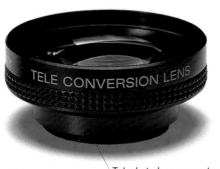

Jack-plug connector

Tangle-free extension cable

▲ External microphone
An external microphone such as this plugs into the appropriate socket on the camcorder (see left). Once connected, it automatically disengages the built-in microphone. Other external microphones include lapel models, zoom microphones, and hand-held units.

Accessories

Lenses

A feature common to all camcorders is the zoom lens. By using a motor to shift the lens in and out, you can close in on, or pull away from, your subject without changing your shooting position. On a camcorder, a zoom lens is nearly always referred to by its magnification ratio, such as 7x, 10x, or 12x. The higher this number is, the greater the range the zoom can cover.

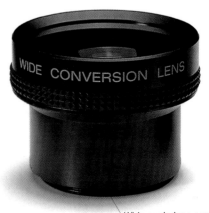

Wide-angle lens converter

Telephoto lens converter

▲ Supplementary lenses
The type of zoom-lens range typically found on camcorders is not suitable for all subjects. When very distant subjects need to be taped, or when a wide angle of view is required, you may need to add the appropriate supplementary lens converter.

16

Filters

Optical special effects are possible with a camcorder simply by adding filters to the front of the lens. The diameter of zoom lenses is not standard, so make sure you buy the correct size of filter for your particular lens. The range of special effects filters available is wide, but in general they should be used with discretion. The results they produce are often intrusive and distracting unless handled with great care. The three examples here are a fog filter with a clear center spot, a starburst filter for turning intense highlights into stars, and a prism filter, which gives a repeating, kaleidoscopic effect of anything positioned center frame.

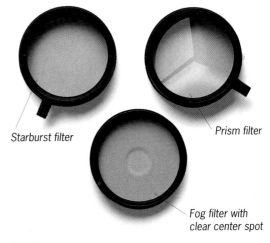

Starburst filter

Prism filter

Fog filter with clear center spot

Lights

Most modern camcorders have sensitive image sensors that are capable of recording watchable, but not necessarily good-quality, pictures in low light. In contrasty light, however, with deep shadows next to bright highlights, a video light will illuminate shadows within about 12ft (3.5m). Some video lights can be handheld, but most are intended to fix into the camcorder's accessory shoe. Camcorders with built in video lights are becoming increasingly popular.

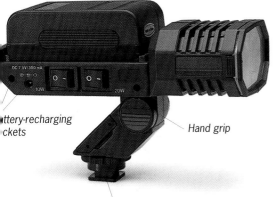

Battery-recharging sockets

Hand grip

Mount for connecting light to camcorder's accessory shoe

17

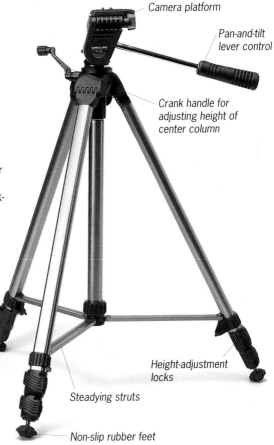

Camera platform

Pan-and-tilt lever control

Crank handle for adjusting height of center column

Height-adjustment locks

Steadying struts

Non-slip rubber feet

Tripod

Most camcorder users are happy to hand-hold their machines while recording, but if critically sharp results are required then a tripod is essential. Rock-steady pictures are particularly important in pan or tilt sequences, for example, when jerky camera movements will cause the subject to appear to jump to different parts of the frame. You have to strike a balance between the benefits of using a heavy, robust tripod and the weight you can comfortably carry. There is no point in having a tripod that is so heavy that you simply leave it in the car. When buying a tripod, pay particular attention to the head. Try out the controls and make sure that its pan-and-tilt movements are smooth and vibration free.

Camcorder features

The modern camcorder is a sophisticated marvel of electronic, audio, and optical engineering. The name 'camcorder' is simply a contraction of the two basic functions the machine performs – *camera* and re*corder*. Only about 10 years ago, a camera operator, sound recordist, and a boom operator would have been required to capture the type of sounds and images achieved routinely today by a single, often palm-sized, camcorder.

How a camcorder works

The camera part of the camcorder consists of a zoom lens and a microelectronic chip known as a charge-coupled device (CCD). The job of the CCD is to convert the light from the subject that enters the lens into a series of electrical signals. The surface of the CCD is covered in a grid of hundreds of thousands of minute photo-reactive cells, each one of which varies its electrical output in direct relationship to the intensity of the light falling on it. In this way, the CCD produces an electronic map corresponding to the variations of light and shade that make up the visible image of the subject.

The output from the CCD is transmitted to the recorder part of the camcorder. This consists of up to four video record heads positioned on a spinning cylinder, around which the video tape is looped. It is these heads that write the signals from the CCD onto the tape as part of its recording function, or read the already recorded signal back again as part of its playback function. The recording of sound also takes place in this area of the camcorder, with the audio signal coming directly from the microphone – not the CCD. With some camcorders the sound is laid down as a separate track; on others, as part of the video signal.

Features and controls

All modern camcorders can be placed on fully automatic, leaving the operator with little else to do other than point the lens in the right direction and press the trigger. However, different models allow varying degrees of manual override. These are designed to allow the camera user to influence the way the images are recorded and to exercise some aesthetic control over the process.

Automatic gain control (AGC)

Camcorders have two AGCs – one to ensure that recorded sound levels do not fall below a predetermined level and the other to ensure that image brightness does not fall too low when lighting levels are poor. They do this by amplifying the electrical signals from the microphone or CCD. There may be situations, however, when you want the sound to be barely audible or the picture dark – when shooting at night, say – and unless you have one of the few camcorders that allow you to switch off the AGCs, this may be difficult.

Backlight compensation (BLC)

This is the most basic form of exposure control the camera operator can exercise. It is designed to allow more light through the lens to compensate for subjects lit basically from behind. Without this, the side of the subject facing the lens would appear shadowy and dark or, in extreme situations, as a silhouette.

Character generator

This feature allows you to add numbers or letters over the recorded image.

Date and time generator

All camcorders give you the option of recording the date and time somewhere on

the screen. This function may be useful for the first few seconds of a taped sequence, or over the opening frames of sequences on a compilation tape to help you identify when each was taken. If left on all the time, however, it soon becomes visually intrusive.

Earphone socket
Allows a headset to be plugged in so that the sound track can be monitored.

External microphone socket
Allows an external microphone to be plugged in. All camcorders have a built-in microphone, but often these are not of particularly high quality and they are also prone to noise interference from the camcorder's motors. There are also times when you need to position a microphone off-camera, close to the sound source.

Fade control
All but the most basic camcorders allow you to fade the sound to silence and the vision to black as a way of achieving scene transitions. This is a very useful feature for in-camera editing.

Manual iris control
Found situated within the lens, the iris consists of a set of overlapping blades. These can be manually rearranged to leave a hole of variable diameter in the center, through which light enters and reaches the CCD. This is a basic method of overriding the autoexposure to give lighter or darker pictures.

Self-timer
This delays the start of recording to allow the user time to get into shot. Depending on the model, some self-timers switch off automatically after a preset period.

Title superimposer
This camcorder feature allows you to recording titles/captions or graphic

symbols, in a choice of colors, over the recorded image.

Twin speed
This refers to the motor that transports the video tape over the video head cylinder or drum. The standard-speed setting gives optimum sound and picture results for any particular camcorder. The long-play option slows the tape transport down so that tape playback time is increased. The result is that more electric signal is packed into any given length of tape and the quality of both the sound and vision is impaired.

White-balance control
Different sources of light – daylight, tungsten, fluorescent, and so on – produce different colors of light. This is not usually noticeable because our brain compensates for these variations, so that we always see, say, a white object as being white. All camcorders have an automatic white balance control that modifies the video signal to compensate for changes in light source. Most also give you the option of manually setting the white balance to fine tune the video signal more precisely.

Zoom lens
Another feature common to all camcorders is the zoom lens. This works by rearranging the internal glass elements making up the lens in relation to each other to give different degrees of magnification. The zoom lens has its own motor, controlled by a rocker switch, to shift the lens in and out. Many camcorders also allow manual zooms. More modern camcorders may also feature a digital zoom, which works simply by magnifying part of the image produced by the CCD. As a supplementary feature, a digital zoom can produce a larger image of the subject once the optical zoom lens has reached its maximum degree of magnification.

19

TWENTY WAYS TO IMPROVE YOUR VIDEOS

There are no unbreakable rules when creating a video. But the more you know and understand about what makes successful and watchable footage, the better your chances of success.

1 · Holding the camcorder

Although it must be said that the best way to achieve steady, professional-looking videotapes is to use a tripod or monopod, the reality is that most people prefer the freedom of using a handheld camcorder. Hand holding doesn't have to be a problem if you adopt the correct shooting stance. This means making your body as rigid a platform as possible without tensing up and causing the camcorder to wobble. Also, try to use things around you as a support for your body or the camcorder itself.

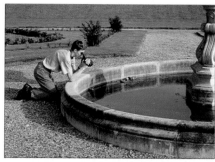

▲ Knees as supports
In this shooting position for low-level images, draw your knees up to a height where they can comfortably support your elbows.

▲ Basic shooting stance
Settle your body comfortably with your legs slightly apart, your shoulders relaxed, and your elbows tucked in to your body. Put one hand through the camcorder's handle to support the machine, leaving your other hand free to operate the controls and provide extra support. When you are ready to shoot, press the record button gently.

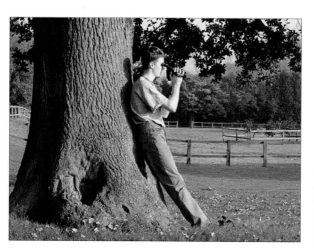

▲ Using a pool's cement wall
In this type of situation, where you want the camcorder as close as possible to the water's surface, rest your elbows carefully on the raised wall around the pool. Don't put too much weight on your elbows, however, or you could graze your skin.

◀ Using a tree
If you can find an appropriate-sized tree near your shooting location, you have a perfect body support. Make sure your feet are squarely planted on the ground with no roots in the way, and then lean back until the trunk takes your full weight.

ADVANTAGES OF USING A TRIPOD

● The average shutter speed of camcorders is about $\frac{1}{60}$ second. Although this is fast enough in most situations to ensure that your material will not look blurred when played back, excessive camcorder movement while taping will cause the images to jitter and bounce about on screen.

● This image was shot in the same conditions as the first one, but you can see the difference using a tripod makes. The frame is crisp and sharp and, when it is on screen as part of a sequence of moving images, it will be more enjoyable to watch.

23

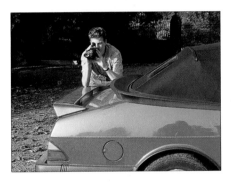

▲ Using a car spoiler
The raised spoilers found on the backs of many cars make convenient supports for your elbows while shooting. Check that the camcorder is level, however.

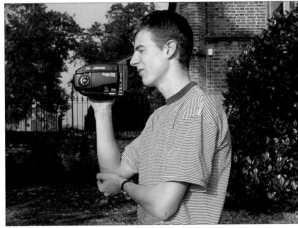

▲ One-handed shooting
Many modern camcorders are so light that one-handed shooting is not a problem. This lightweight construction can cause the camcorder to move about quite a bit while shooting, however. One way to minimize this is to use your free hand to support your other elbow.

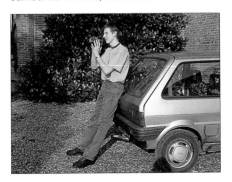

▲ Supporting your weight
When a tree is not conveniently available (see opposite), you can use the sloping back of your car in much the same way to support your weight when shooting.

USEFUL TIPS

● To prevent your horizons from sloping uphill or downhill, always make sure that you are holding the camcorder straight and level before shooting.

● When choosing a tripod, make sure that the platform on top is broad enough to support a camcorder. Also ensure that the pan-and-tilt controls are fluid and smooth and that, overall, the tripod is sturdy enough to provide good support without being too heavy to carry.

2 • Coping with light

The quality and intensity of natural daylight can be extremely variable. The time of day you shoot – early morning, noon, or late afternoon, for example – has a dramatic impact on the way light affects your subject. You also need to take into account the direction from which light strikes your subject – the front, side, or back – the degree of overcast or open sky prevailing at the time, and whether or not light reaches your subject directly or has been bounced off intervening surfaces.

▶ Backlighting

Subdued, moody lighting can be difficult to achieve with many camcorders because the automatic gain control (see pp. 18-19) boosts the signal to bring it up to a predetermined 'normal' level. One way around this is to position your subject against the light so that it is slightly underexposed. If the exposure difference between your subject and background is very great, however, your subject may turn into a featureless silhouette.

1

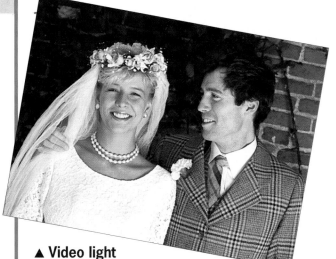
2

24

▲ Video light

These newlyweds have been taped just as they were leaving the church. The natural lighting on that day was overcast and dull, with the sun completely obscured by clouds. If they had been videoed without the benefit of any supplementary lighting, the results would have appeared flat and lifeless due to the lack of contrast. The solution here was to use a high-powered video light attached to the accessory shoe on top of the camcorder. Although this lighting effect is harsh and not particularly attractive, it added much-needed contrast.

▲ Reflected fill-in light

When your subject is only partially lit – because, say, the light from a window is falling on just one side of his face – the contrast between the highlights and shadows can be too severe. One solution is to bounce additional light onto the shadowed side of the face, as above, by positioning a piece of white posterboard (out of shot) opposite the light source.

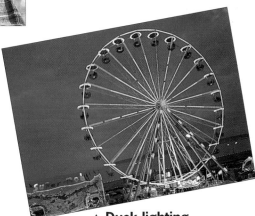

4

3

USEFUL TIPS

● When you are using a portable video light, if possible hold it at arm's length so that its light strikes your subject from a slight angle. If you have an assistant, try pointing the light at the ceiling or a wall, so that a softer, less harsh light is bounced onto your subject.

● If your subject is very strongly backlit and you don't want a silhouette effect, use your camcorder's backlight-compensation control (if it has one) to open up the lens iris.

▲ Dusk lighting

At dusk, there is often still enough natural light available to give form and modeling to features in the scene. You will also benefit, as in this fairgrounds shot, from the additional colored effects of any artificial lighting. Although it is not strong enough to affect exposure, it does add mood and atmosphere.

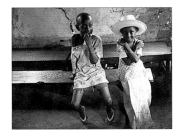

▲ Bright indoor lighting

Dark-skinned subjects need higher light levels than fair-skinned ones for correct exposure. Here, strong sidelighting was supplemented by light from in front of the subjects.

▲ Mixed lighting

The principal light source here was natural window light, supplemented by a little domestic tungsten. Set the white-balance control on your camcorder to suit the main light source.

▲ Stage lighting

Camcorders are able to cope well with typical stage lighting levels, even if subject colors are not quite 'normal.' However, contrast between lit and unlit parts of the scene may be harsh.

3 · Coping with the weather

The sensitivity of the charge-coupled device (CCD), which translates the light coming in through the lens into an electrical pattern that can be recorded by the videotape, allows you to use your camcorder in bad weather when light levels are low. However, best results are likely to be had in bright, even sunlight where there is not a too much difference, in terms of exposure, between adjacent highlights and shadows. But don't neglect inclement weather conditions, since they can add drama and atmosphere.

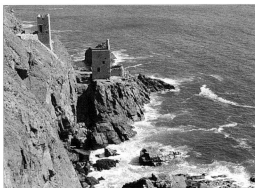

26

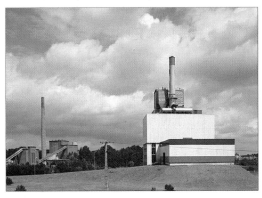

▲ Variable sunlight

In terms of exposure, the two most successful frames here are top left (lit by open sky) and bottom right (bright cloudy daylight). In the other two, the sun is directly illuminating parts of the scenes, creating bright highlights and deep shadows that the tape has difficulty coping with.

◄ Shooting into the sun

The contrast in this scene is extreme. The camcorder has been oriented so that the sun is shining directly into the lens. The autoexposure system has registered the extremely high light levels and reacted by closing the iris down. As a result, all of the scene, apart from the area of sky surrounding the sun, is underexposed. This, however, is not necessarily a mistake. Certainly if you wanted to show detail in the land area, you have a problem; as a finale, however, this shot could make an ideal background against which to show your closing credits.

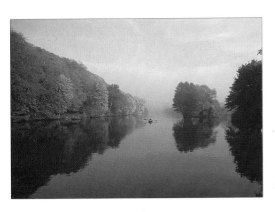

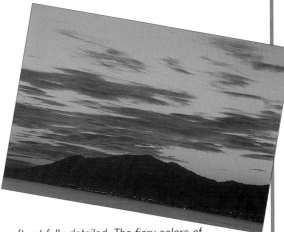

▲ Early morning and sunset

The quality of the light early in the morning and at sunset is like no other. In the early morning, the air is still and the shadows cast by the low sun can be soft yet fully detailed. The fiery colors of sunset result from the scattering of light in the often gritty atmosphere it shines through.

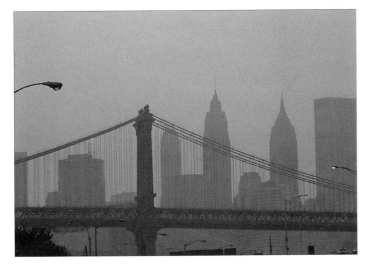

27

◀ Dusk

After the colors of sunset have left the sky, there is often still sufficient twilight remaining to give quite good subject detail. This is also the time of day when the city lights start to wink on, providing a valuable source of evocative illumination.

▶ Contrasting conditions

The amount of detail your camcorder can record depends partly on the clarity of the atmosphere. Compare these two shots – one taken of a factory in Eastern Europe and the other in the Canadian Rockies.

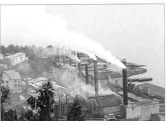

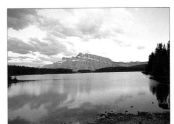

◀ Rain

The poor light levels usually associated with rainy weather don't represent much of a problem for a modern camcorder. Ideally, find some cover to shoot from so that your camcorder doesn't get wet. If this proves impossible for some reason, then wrap the camcorder in a plastic bag with holes for the lens and viewfinder to poke through.

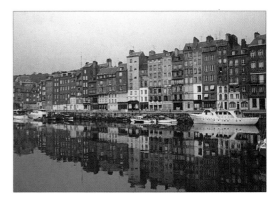

▲ Dull and overcast lighting

When the lighting is dull and lacking in contrast, results can appear flat and uninteresting. With some subjects (above left) you could introduce artificial *illumination (see p. 17), but with a general view (above right) find an angle to shoot from that maximizes whatever contrast may be present.*

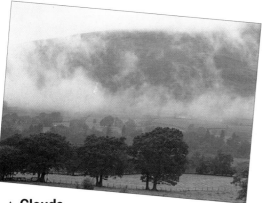

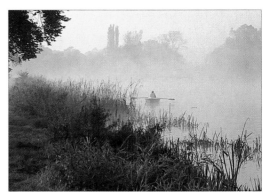

▲ Clouds

Clouds can add interest to any type of landscape subject. If the clouds are being directly illuminated by the sun, then the countryside below them may seem a little dark in comparison, but this can work to your advantage by adding to the dramatic impact of the scene.

▲ Mist

Misty weather conditions tend to even out the lighting, lessening contrast but introducing a sense of mystery. The problem of contrast was overcome in this example by positioning the dark mass of the grassy bank very close to the camcorder lens – thus making the image strongly three dimensional.

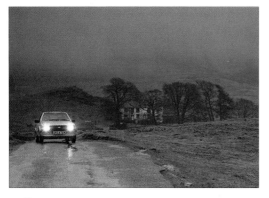

▲ Storm

As the clouds start to mass, there is often a tangible feeling of tension before the full force of the storm actually breaks. This type of scene is ideal for the camcorder to catch, along with the dramatic lighting and sound effects.

USEFUL TIPS

● To maintain some detail in the foreground when shooting directly into the sun, use your camcorder's backlight-compensation control (if it has one). This opens up the lens iris, allowing more light to enter.

● If your framing is tight on a subject and the weather is dull and overcast, try positioning simple, white posterboard reflectors to bounce any available light onto your subject.

● When the air is dusty, full of sand, or it is raining, take precautions to protect your camcorder. A plastic bag with holes cut for the lens and viewfinder will often do. If your camcorder does get dirty or wet, clean it thoroughly but carefully, and according to the manufacturer's instructions, as soon as possible.

28

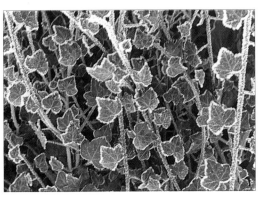

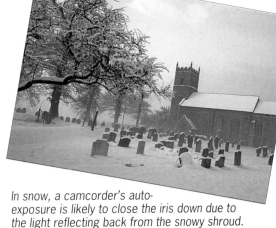

▲ Frost and snow

Unless the weather is cold, frost (like that on the ivy above), does not last long after the sun has risen, so work quickly to take advantage of the conditions.

In snow, a camcorder's auto-exposure is likely to close the iris down due to the light reflecting back from the snowy shroud.

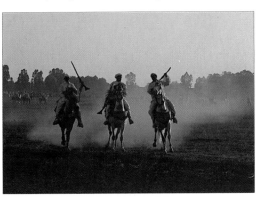

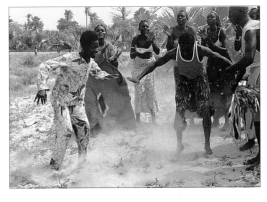

29

▲ Dust and sand

Although you can regard dust simply as a problem you need to protect your camcorder from, visually it can add excitement to a tape, helping to give your audience some sense of what it was like being there. In the horse shot, dust filters the light

behind the riders, creating a constantly shimmering highlight. With the dancers, the sand being kicked up is all part of the rhythm of the scene, along with the clapping and singing on the soundtrack.

◀ Smoke

The series of fires seen here throws clouds of smoke into the air, forming a thin blue haze in the air. The small fires rippling across the landscape provide a contrasting, warm-colored highlight in a scene otherwise dominated by a cold, blue-white sky. The drama of the scene is heightened further by the dark, silhouetted form of the lone farmer placed against the much brighter skyline.

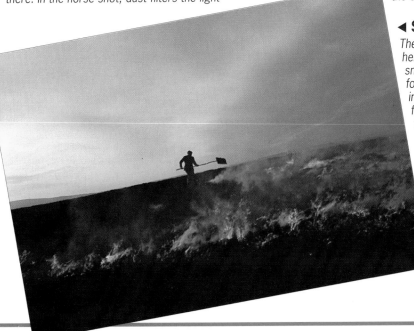

4 • Dealing with contrast

Contrast – the difference in exposure between bright highlights and deep shadows, or the perceived difference between different intensities of color in a scene – helps to bring your tapes alive on the screen by adding depth, distance, and eye-catching appeal. However, if the contrast range is very great, the camcorder's autoexposure system may adjust the lens iris in favor of one end of the range – the shadows, say – at the expense of the other, resulting in pale, washed-out highlights.

▲ Focusing and exposure

In the first two images above, the camcorder has set its exposure for the large area of sky, leaving the subject underexposed. In the third frame, the focus has been corrected so that the main subject is now sharp. Although the exposure remains the same, you can see immediately the improvement in contrast. In the final, tighter-framed shot (right), the sky plays a less dominant role in the composition and, so, exposure favors the subject. Colors are brighter and better defined, and the contrast makes the image appear sharper still.

▲ Shooting with the light

When the sun, or any other source of illumination, strikes the side of the subject facing the lens, colors tend to be bright and subject detail well defined. This is known as shooting with the light.

▲ Shooting against the light

When the light strikes the side of the subject away from the camcorder, colors facing the lens tend to become more intense. If the contrast is extreme, shooting against the light will produce a silhouette.

▲ In the rain

When the sky is overcast and the rain is falling, the light does not come from any particular direction. This type of situation inevitably leads to a dramatic lowering of contrast, since there is little exposure difference between shadows and highlights.

▲ Reframing the foreground

By reframing the shot to feature the foreground bed of bright flowers, there is now a distinct difference in exposure between the flowers themselves and the area of lawn beyond. Contrast has been increased and the scene has more visual interest.

31

▲ Sunshine

Morning or afternoon sunlight, when the sun is not directly overhead, often produces the best subject color. Midday sunlight can be too contrasty, with adjacent areas of the subject either brightly lit or in extremely deep shadow.

▲ Overcast sky

To relieve the flat, low-contrast light of an overcast sky, look for a splash of color or a reflective surface, such as the river in the shot above, to add an important area of highlight and brightness.

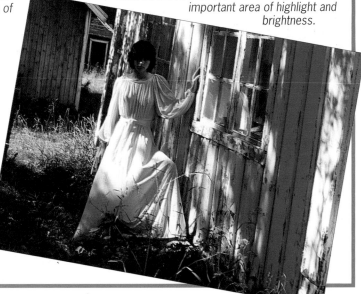

▶ Extreme contrast

Videotape does not cope well with extreme-contrast lighting; either the shadows become unreadably dense or the highlights burn out and are featureless. If faced with this type of situation, look for a shooting position where the subject is illuminated by less-extreme lighting, or use a reflector or video light (see p.17) to lighten the shadows and thereby reduce the level of contrast overall.

5 · Shooting angles

Because of its lightness and ease of operation, the temptation when using a camcorder is to walk around, taping material as you go. As well as producing unsteady images and inconsistent framing, this approach also pays scant attention to the need to find the most interesting and revealing angles for any particular event or activity. Don't become so fixated on the principal subject that you fail to notice how the shooting angle affects all the other elements making up the scene.

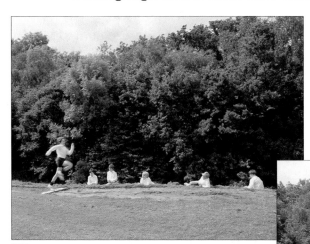

1

▲ Side-on vantage point

Coverage of this sports day long jump commences with the camcorder showing a side-on view of an athlete sprinting down the track, reaching the take-off point, and leaping into the air. This shooting angle is best for conveying the distance jumped, since there is no perspective distortion, but it is not necessarily the most exciting one.

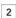

◄ Head-on vantage point

The sporting activity is the same here as in the sequence above. Now, however, the camcorder has been repositioned to show a head-on viewpoint, with the long jumper leaping directly toward the shooting position. Although this shooting angle does not show the technical merits of the jump as well as a side-on view, it does make a far more exciting action sequence. If you want, you can use sequences of the same athlete making two jumps – one taken side-on, or at about 45˚, and the other taken head-on – and then edit them both together afterwards (see pp.154-55).

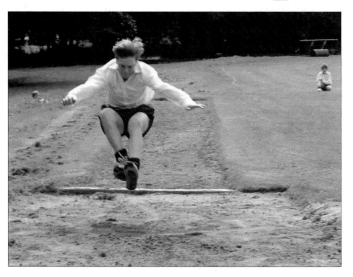

▶ Shooting height

This sequence of images is of the exciting finish of a traditional egg-and-spoon race for the younger competitors at the sports day. The level of the camcorder has been carefully planned so that it is approximately in line with the subjects' eyes. If the scene had been shot from a normal adult's standing position, the camcorder would have been looking down on the tops of their heads – especially as they drew nearer to the camera position.

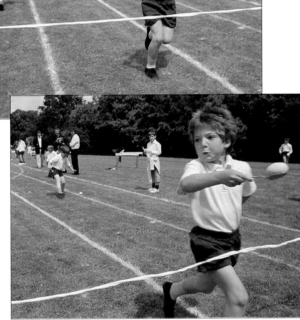

USEFUL TIPS

● You can use high or low shooting angles to eliminate potentially distracting or unappealing backgrounds. A high shooting angle, with the camcorder looking down, may show the main subject against a neutral backdrop of grass, for example. A low shooting angle, with the camcorder pointing up, may show your subject against a plain background of sky – but you may then have to use the backlight-compensation button to avoid underexposing the subject.

● Varying camera angles for different shots provides additional interest, as does varying the length of individual shots. Quick cuts between shots gives a sense of excitement.

33

▶ High angle

A high shooting angle was chosen for this scene of the awards ceremony to help convey what the individuals must have felt as they came forward to receive their prizes. From the tiered stands, the camcorder shows the head teacher and the winners against a backdrop of hundreds of other competitors and parents.

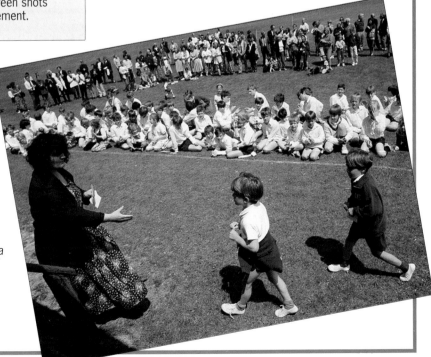

6 · Shot sizes

There is a whole video language – adopted from the movie and television industries – devoted to describing different shot sizes. A tape invariably starts with a long shot (LS), which is also known as an establishing shot. The purpose of this type of shot is to orient the audience so that it can see where the material that follows is taking place. A mid-shot (MS) brings the audience closer in to the action. Using the human figure as a yardstick, an MS would extend from about the waist up. An ordinary close-up (CU) would encompass only the head and shoulders of the subject, or any detailed, confined area of an inanimate object.

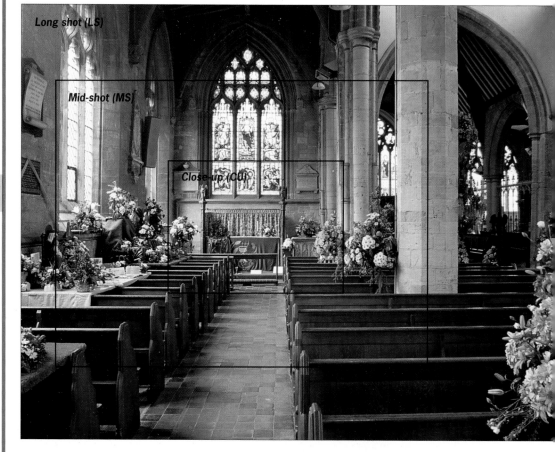

Long shot (LS)

Mid-shot (MS)

Close-up (CU)

34

▲ Other types of shot

As well as the three most commonly used shots described above, there are also other types of shot. Using the human body as our yardstick once more, a big close-up (BCU), for example, would frame the subject closer than an ordinary CU and take in, say, the face alone. At the other end of the spectrum, there are also what are known as very long shots (VLS) and extreme long shots (ELS), which are both extremely wide long shots. A shot set up so that a single person is seen in MS is sometimes described as a one-shot, and when two people can be seen, as a two-shot.

USEFUL TIPS

● Although a taped sequence should contain a good range of long shots, mid-shots, and close-ups to hold the audience's attention, varying the shot size every time you cut may make the action seem almost comical.

● You can justify a shot size change by showing the object in LS before moving in to an MS.

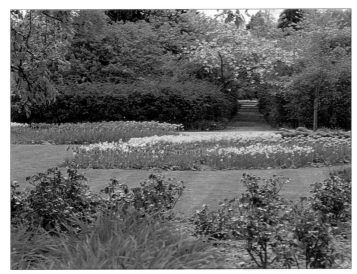

◄ The long shot

If used as an establishing shot, the long shot tells the audience where the action that follows is taking place. The long shot invariably uses the wide-angle end of the camcorder's zoom lens, which also makes it the favored setting for recording broad panoramic views, some street scenes, and cityscapes.

► The mid-shot

This type of framing can be used as a bridge between a long shot and close-up. It often produces a neutral type of atmosphere, providing the audience with a more detailed view than an LS while not entering the personal space of the subject that is implied by a CU. Note, too, that the depth of field – the amount of the scene that is in sharp focus – decreases as the lens moves toward the telephoto end of its zoom range.

35

◄ The close-up

Use close-ups when you need to show the subject, or part of it, in great detail. Bear in mind, however, that any errors in focusing or poor camera handling (see pp. 22-23) will then be far more evident. The close-up may also critically reveal any imperfections in your subject.

7 · Composing a shot

A thoughtfully composed sequence of images, in which the foreground, middle ground, and background all play a positive part, will be more enjoyable to watch on screen than one in which little thought has been given to these composition elements. Bear in mind that the television screen on which the audience will see your tape is not large in comparison with a movie screen, so it is best to use predominantly mid-shots and close-ups in preference to long shots, which can look empty and lack interest.

36

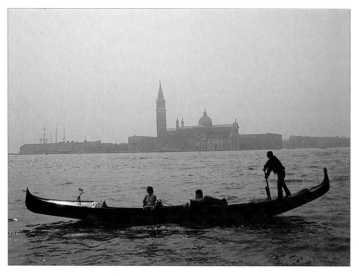

▲ Low horizon
This cityscape has been composed with the horizon low in the frame, which gives the image a airy sense of space.

▲ Filling the foreground
This image across the lagoon at Venice works particularly well because the shot was timed to incorporate the foreground gondola. Without it, the expanse of empty foreground water would have weakened the overall effect.

▼ Foreground frame
This example has been composed so that the foreground elements give a sense of place to the setting as well as helping to fill the frame. The contrast between the mountains, lake, and shadowy trees adds depth.

▲ Middle horizon
In this alternate framing, the horizon is centrally positioned, which gives equal emphasis to the buildings and water.

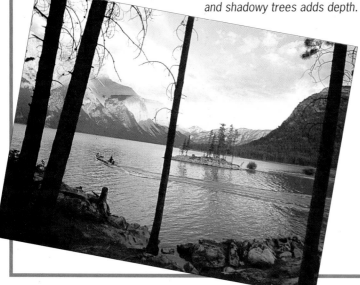

▲ Change of framing
Zooming in so that the buildings dominate the scene communicates a definite emphasis and creates a more enclosed image.

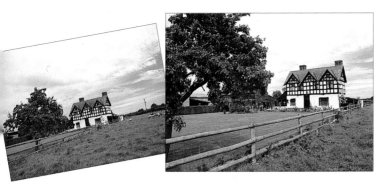

◄ Lead-in lines

These two views of the same subject illustrate the strength-ening effect that 'lead-in' lines can have on a composition. In the first (far left) the house looks lost in the foreground field. In the second (left), how-ever, changing the viewpoint slightly to include the fence, leads the viewers' eyes exactly where you want them to go.

▲ Linking foreground and background

The rich detail of the foreground and middle-distance field of young wheat, with the darker area running diagonally through the frame where the crop has been slightly flattened, helps to integrate the nearer image planes with the background of agricultural buildings. The result is a picture that the eye can explore at length.

USEFUL TIPS

● Although the camcorder is obviously ideal for moving subjects, a lot of video footage is taken of landscapes and other types of static views. This gives you ample opportunity to put some of the compositional devices described here into practice.

● Using the wide-angle end of the lens's zoom range has the effect of opening out the image planes – foreground, middle ground, and background – and introduces more of a sense of space into your composition. It also tends to make near objects seem disproportionately large in relation to far objects, and so exaggerates depth and distance.

● Using the telephoto end of the zoom range tends to compress the image planes, which can help to link them all together.

37

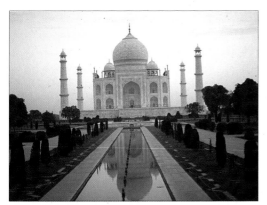

▲ Introducing perspective

India's famous Taj Mahal is seen here in soft, morn-ing light. The strong impression of depth has been created by the composition, which shows the parallel sides of the foreground ornamental pond seeming to converge as they approach the back-ground mausoleum. This convergence has been heightened by the shooting angle of the camcorder to give the scene depth and distance.

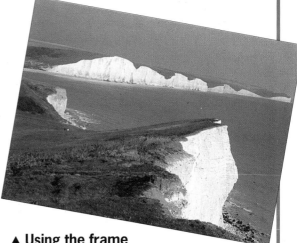

▲ Using the frame

The chalky exposed faces of these towering cliffs act as 'stepping stones' to lead the viewers' eyes throughout the entire frame. The meandering shape described by the cliff tops also invites the eye to explore the rich detail of the imagery. Although this is largely a landscape shot, including the tiny figures in the middle ground helps to give a sense of scale.

8 · Using your surroundings

When looking through the viewfinder, it is all too easy to concentrate on the main subject and fail to notice the way the surroundings affect the impact of the shot. This is especially true because the viewfinders in many camcorders are small, rather uncomfortable to use for long periods of time, and often show only a black-and-white image. Sometimes, just a slight shift of shooting angle to the left or the right can make a huge difference to a scene's overall composition.

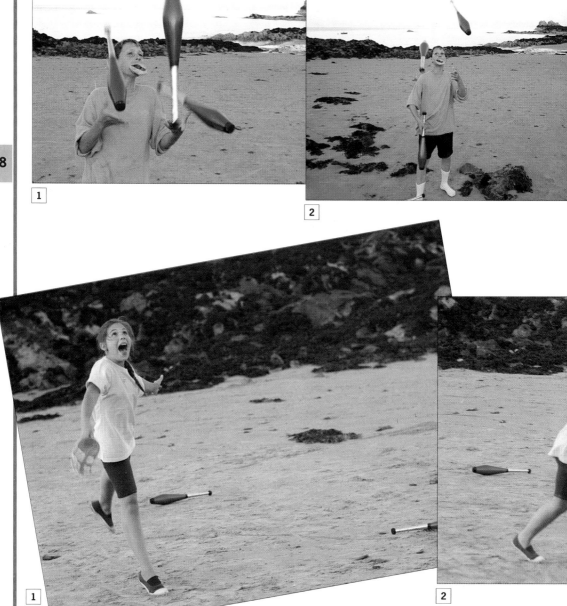

38

▼ Plain surroundings

The main point of interest in this sequence of shots is, of course, the juggling. These two young jugglers were taped while practicing on an empty beach early in the morning. They have been framed so that the Indian clubs being thrown between them can be clearly seen against a largely plain and uncluttered background. Even the flat-toned white sky is an advantage here.

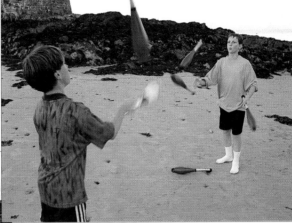

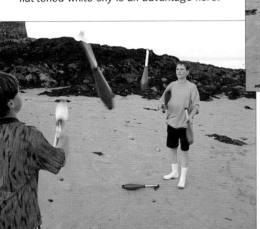

4

USEFUL TIPS

● If you are using a camcorder that has a black-and-white viewfinder display, it is important to check with your naked eye from time to time the effects that the color of the background is having on your subject.

● Use the defined edges of the viewfinder display as an aid to composing your image.

3

◄ Using color

This sequence was shot at the same location and at about the same time as the one above. Here you can see how well the plain, dark background of out-of-focus rocks acts as the perfect foil for the vibrant orange and green colors of the scoop and ball. If the camcorder operator's anticipation had not been as good, and if the subject had been shown in anything other than a featureless setting, the impact of the sequence would have been diluted.

9 · Framing the figure

It is the attention you pay to detail that can make or break a video sequence. One of the most important aspects of videotaping people is framing them so that they look 'comfortable' on screen. To do this you can follow the 'natural cropping lines' for both close-ups and mid-shots, as explained below and opposite. It is not only the amount of your subjects' bodies you show that is important, however. Equally vital is where you position them within the frame and how you arrange the space around your figures.

◀ Central framing

Placing your figure center frame gives the subject great prominence, but it is also the least dynamic of your framing options. Off-center framing, even in close-up, often creates a more visually engaging image. If this shot had been an ordinary close-up, not a large close-up, the framing here would have been uncomfortable.

USEFUL TIPS

● Use the lens zoom control to determine the best framing for your figure. Only after you have found it should you start to record.

● Zooming in on your subject enlarges the background as well as the figure. This can alter the visual impact of your shot. If you don't want to give the background extra prominence, it may be better to set the lens to a wider angle and move in closer to make the figure larger in the frame.

▲ Looking space

It is easy to make the mistake of framing your subjects so that they are looking to the side of the image area. In the shot above, the elderly couple have been framed so that they are on the extreme right of the frame, looking toward the right. You can see how uncomfortable they look. If their faces had been turned the other way, so they had free space to look into, the shot would have worked far better. The profile of the woman on the right is better in this regard. She has been placed to the right in the frame, looking into the free space on the left.

▲ Framing two-shots

Two-shots are shots that feature two people. In the mid-shot above, the lens has been set so that the figures are cut off at about the waistline. This is one of the natural cropping lines for such a shot. In the other two examples, both ordinary close-ups, the natural cropping line is at the shoulders. It is interesting to note that the more the figures overlap, rather then being arranged in straight lines, the more energy the composition seems to convey, even though all the figures are stationary.

41

▲ Natural crops

Regard all rules as guidelines only – they are not written in stone. In the first image of this subject (above) the framing was largely determined by the woman's hair – unless you wanted a big close-up of the face alone, cropping off part of her hair would have spoiled the shot. Likewise with the the next shot (right). Here the natural cropping point was at her elbows. Coming in just a little tighter would have made her arms look very awkward. Check for yourself by covering up the bottom part of this image.

10 · Controlling focus

Focusing is more than simply keeping the subject sharp. It is a way of emphasizing the relative importance of the different elements making up the scene by showing some of them in focus and others not. You do this by using the depth of field – the amount of the scene in front of and behind the point of focus that is also sharp. A long focal-length zoom setting and a wide aperture give you a very shallow depth of field, while a short focal-length setting and a small aperture should render the whole scene sharp.

▶ Pulling focus

This technique involves manually altering, or pulling, the focus setting so that specific elements of the scene change from being in focus to out of focus, or vice versa. In the sequence illustrating the technique here, frame 1 starts with the ornate lamp in sharp focus and the view behind blurred. In frame 2, the focus has been pulled to reverse the emphasis, with the lamp blurred and the background sharp. This is one way to justify a change in shot size or a scene transition. By drawing the audience's attention to the lake through controlling the focus, the cut at frame 3 to a closer view of the boat and mountains seems perfectly natural.

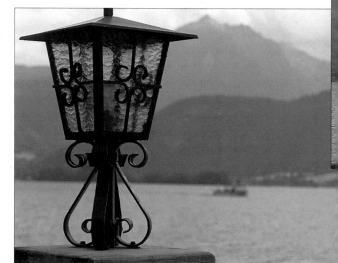

42

▶ Follow focus

Follow-focus techniques are used when you have a subject moving either toward or away from the camcorder position, or one moving diagonally across the field of view of the lens. This makes it necessary to change the focus setting while taping to keep the subject sharp throughout. All camcorders today have an autofocus feature, which, in the majority of cases, keeps a centrally framed figure in focus as it moves about. However, some autofocus systems shift the lens backward and forward, searching for the sharpest possible setting, which can look amateurish and distracting on the finished tape. Often, it is best to take the camcorder off its automatic setting and focus manually, using the viewfinder image as your guide.

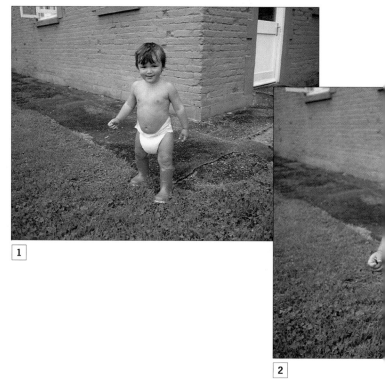

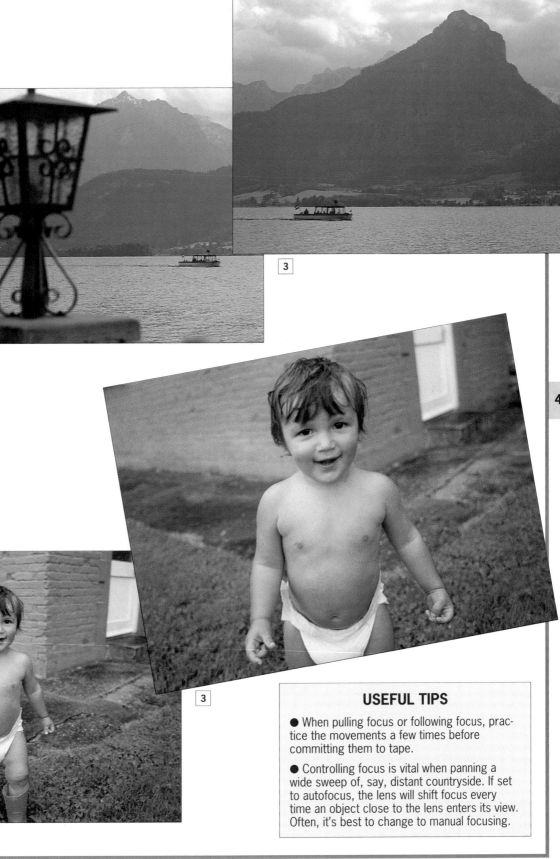

3

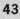

43

3

USEFUL TIPS

● When pulling focus or following focus, practice the movements a few times before committing them to tape.

● Controlling focus is vital when panning a wide sweep of, say, distant countryside. If set to autofocus, the lens will shift focus every time an object close to the lens enters its view. Often, it's best to change to manual focusing.

11 • Using the zoom feature

Of all camcorder features, the zoom lens is probably the one most used to bad effect. The real advantage of having this feature is that you can zoom in and out to find the best subject framing *before* you start to record. Most frequently, however, the zoom is used during recording in an almost whimsical fashion – as if the user just wants to have a closer look at something in the viewfinder before zooming back out again to the original position. The effect on screen can be almost unwatchable.

▶ Zooming back

This sequence of images starts off with the lens set to the telephoto end of its zoom range so that the flowers can be seen in detailed close-up. After holding this shot for approximately 4 to 5 seconds, the lens was slowly zoomed back so that, on screen, the audience could start to see these flowers in the context of the neighboring plants in the bed. The next part of the sequence then consisted of a slow pan to the right so that all of the flower bed was revealed to the audience piece by piece.

1

44

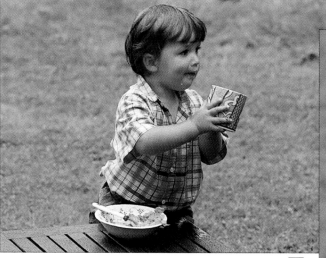

1

2

▲ Zooming in

This sequence starts off in mid-shot with the little boy holding out his empty mug, which, by the look of his face, must have contained milk. The lens is then zoomed in quite quickly to a close-up so that the audience can see his expression in better detail. After this, the scene cuts to a different shot altogether. As it is, this use of the zoom is fine, but to have zoomed back out again to a mid-shot would have ruined the dramatic effect.

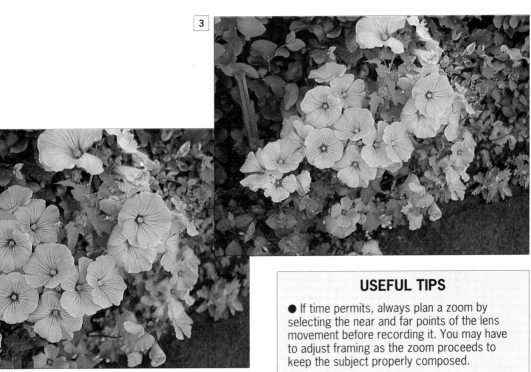

USEFUL TIPS

● If time permits, always plan a zoom by selecting the near and far points of the lens movement before recording it. You may have to adjust framing as the zoom proceeds to keep the subject properly composed.

● As you record a zoom, bear in mind that the exposure may vary as brighter or darker subject elements come into view.

45

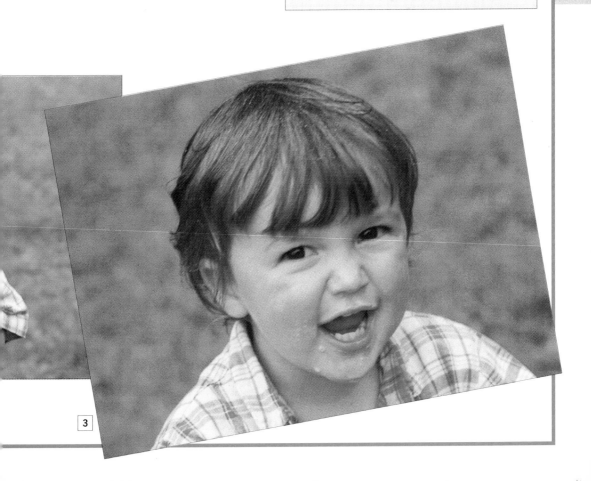

12 · Direction of movement

You can handle movement across and through the frame in different ways. Don't think that you have to move the camcorder just because your subject is moving. In fact, the opposite is often true; leaving the camcorder stationary lessens the possibility of confusion. One of the chief types of confusion occurs when the camcorder crosses the imaginary line of movement of a subject – framing part of a sequence from the left-hand side of the subject, part from the right, for example.

▼ Movement across the frame

With this type of movement across the frame, either keep the camcorder stationary so that the subject enters on one side and exits on the other at her own pace, or pan (see pp.50-51) at a slightly slower speed than the subject to keep her in view for a longer period.

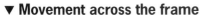

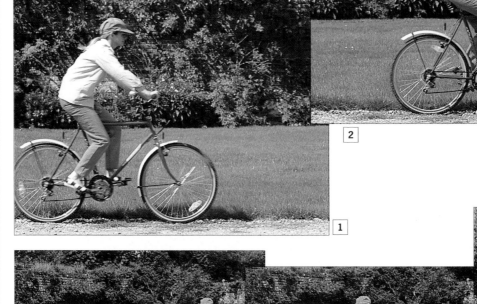

▲ Movement through the frame

Keeping the camcorder still often works best with this type of diagonal movement, too. After the subject has exited the frame, you then have a natural point in the visuals at which you could decide to cut to another scene. If the subject, as here, is well out of the target area of your camcorder's auto-focus system when entering the frame, it may be best to override the automatics and focus manually (see pp.42-43).

46

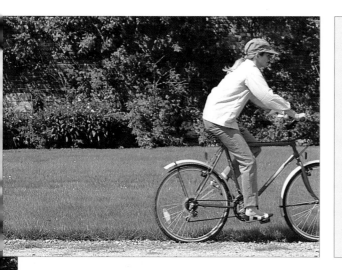

▶ Crossing the line

You can see in this sequence that frame 1 was shot from the right-hand side of the road while frame 3 was shot from the left-hand side, and the car appears to have reversed direction. This is known as 'crossing the line.' The only reason why this apparent reversal does not look odd here is because the intervening frame 2 has been shot directly on the line of movement itself. Cover up the middle frame to see how disjointed the other two would look without it.

47

1

2

3

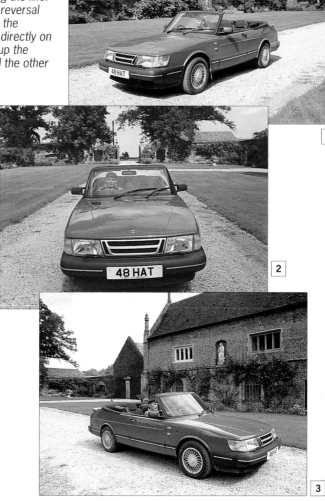

3

13 • Framing a moving subject

There are different ways to tape a subject moving past your position. The usual way is to pan – that is, to swivel the camera to keep the subject in view (*see pp. 50-51*). A more difficult option is to track alongside the subject with the camcorder while trying to keep the image steady (see pp. 52-53). A third option is illustrated below. No matter which one you choose, always try to keep the subject in the same part of the frame throughout to keep the figure from appearing to weave all over the screen.

▶ The subject approaches

For this first sequence, the camcorder was set up on a tripod to one side of a country road, allowing enough room for the cyclist to be able to draw level and pass the camcorder position. As she approached, the autofocus was able to track her progress and keep the image sharp. In all the shots making up this sequence, the cyclist occupied much the same area of the frame. Obviously, as she drew nearer she also appeared to become larger, and so took up more of the frame. When the cyclist was almost level with the camcorder, the pause button was pressed and the camcorder swiveled to tape the next sequence.

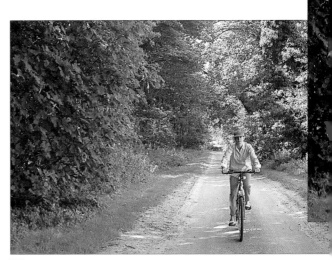

`1`

`4`

▲ The subject recedes

Taping resumes, and now we can see the back of the cyclist receding into the distance. Again, the autofocus had no trouble tracking her progress and maintained a sharp image. As before, the most important job for the camcorder operator here is to ensure that the framing of the sequence remains constant throughout. This task is made much easier by using a tripod.

`5`

48

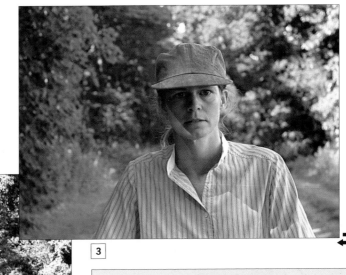

3

USEFUL TIPS

● An easy way to ensure that your framing remains steady when taping a a series of shots is to align the viewfinder image with some key features within the scene. You might, for example, position a tree branch at the top right-hand corner of the frame and an uneven edge of the road at the bottom left-hand corner. With these markers in sight as you look through the eyepiece, you can then tape the subject traveling across the viewfinder, knowing that your results will look professionally framed and steady throughout the entire sequence.

● The transition between the two simple sequences that make up the example illustrated here appears to be very smoothly executed because the subject is approximately the same size in the viewfinder at the end of the first sequence as at the beginning of the second sequence.

49

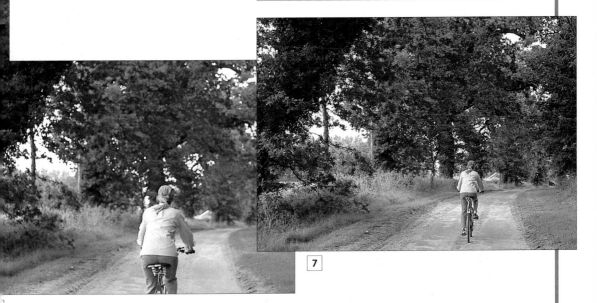

7

14 • Pans and tilts

Two common camcorder movements are pans and tilts. With a pan, you move the camcorder sideways, left to right or right to left, while standing in the same position. The most usual reason for panning is to show a panoramic sweep of countryside or an expansive city skyline, or to keep a moving subject within the field of view of your lens. A tilt involves pivoting the camcorder up or down from the same shooting position, in order to emphasize, say, the height of a building by revealing it bit by bit.

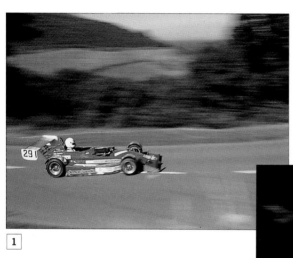

1

2

3

▲ Keeping up with the action

This sequence of a speeding racing car is a classic example of when you might pan the camcorder in order to keep the subject in view. You could decide to zoom the lens back to its widest setting to show the car without panning, but then it would appear small and insignificant and have very little on-screen impact. The speed of the pan determines how the stationary elements of the scene will appear. A very rapid pan, for example, may show the background as blurred and streaky, and so help to emphasize the car as the main subject, since this part of the image will still be sharp. This could be very important if, for example you can't get close enough to the action to bring up the subject particularly large in the frame, even at the longest zoom setting the lens has to offer.

USEFUL TIPS

● Like all camcorder movements, pans and tilts will, in nearly every case, be more successful if you rehearse them before committing them to tape. To do this, first use the lens's zoom control to set the framing that best suits the subject and then, while studying the image through the viewfinder, decide where to start and finish the movement. Look for prominent, positive features to mark your start and end points. Only after you have practiced the movement once or twice should you run the tape.

● You can use panning simply and effectively to make a moving subject exit the frame. All you have to do is let the pan lag fractionally behind until the subject is out of sight.

50

▶ Revealing the subject

In this sequence, a tilt has been used to reveal the Canary Wharf Tower, which is part of a massive new development in the former dockyard area of London, England. The tilt sequence starts at the top of the building and finishes at street level. In this way you can greatly emphasize the subject's height and importance by showing the structure in a piecemeal fashion. You could also start your tilt at street level and finish at the top – it all depends on what the next shot shows. Finishing at the bottom would be best if you were then to cut to another street scene, for example. Finishing the tilt at the top, with the sky in view, might be the perfect point to cut to another type of scene or setting altogether, such as an interior shot of an apartment or office.

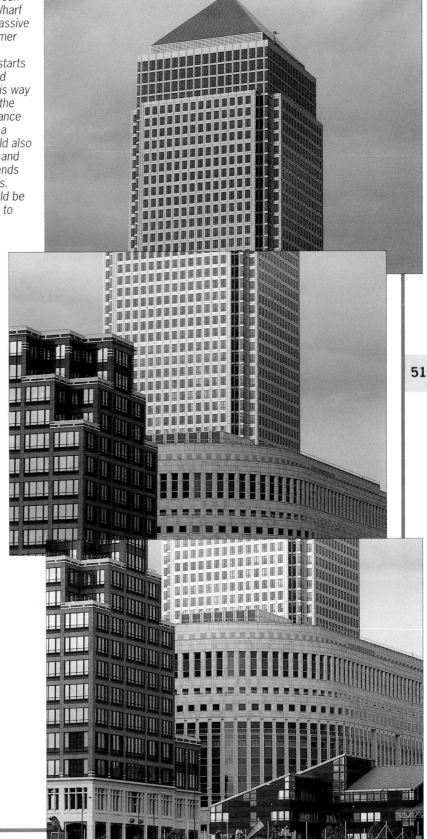

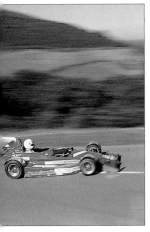

15 · Tracking shots

Instead of panning the camcorder to encompass a panoramic view (*see pp. 50-51*), you can use another camera movement known as tracking. When tracking, the camcorder moves as the recording is being made. This technique, however, is not usually applied to a static subject, such as a landscape view. Instead, you will most often see it on television and at the movies when the camera tracks alongside a moving subject, such as a walking person or a car being driven down the street.

▶ Planning your approach

The major problem when trying a tracking sequence is that it is difficult to keep the camcorder steady while walking alongside a moving subject. You can buy a special hydraulic camcorder support designed for hand-held tracking shots, but it is expensive and cumbersome to use. It is probably worth considering only if you are a member of, say, a videomakers' club and your group is thinking of putting together more-ambitious productions. Tracking sequences can be far more successful when taken from a moving car, especially if the road surface is in good condition and the driver keeps the gear changes smooth. Professional tracking shots are accomplished in the studio by using a dolly-mounted video camera or, on location, by laying a set of small gauge railroad tracks and mounting the camera on a special wheeled platform. Having said that, you should not be dissuaded from attempting a few tracking sequences, and if a little jiggling of the image is apparent as you walk along, this can add a certain realism to the coverage. The sequence here is typical of the type of subject you may want to experiment with. Trams and trolley cars are relatively slow moving and follow a fixed route along their tracks, so there won't be any surprise moves to throw your concentration off. Keep your walking pace steady and your body relaxed.

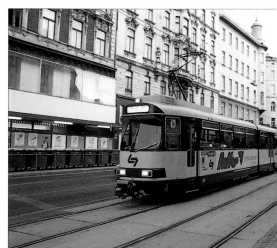

1

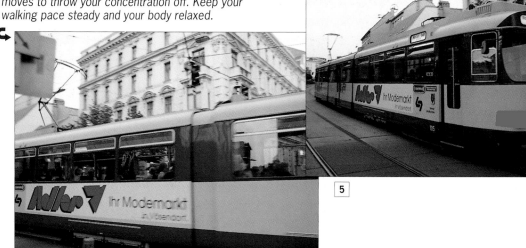

5

4

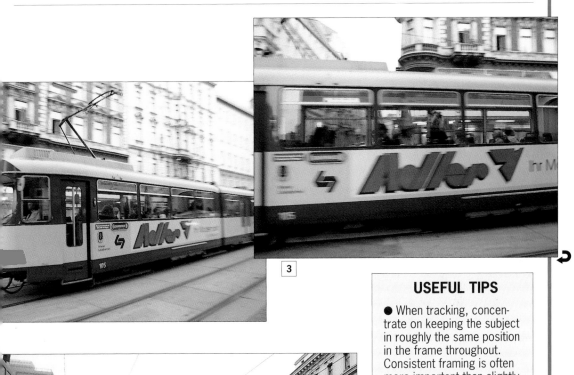

3

USEFUL TIPS

● When tracking, concentrate on keeping the subject in roughly the same position in the frame throughout. Consistent framing is often more important than slightly jiggly images.

● Many types of video tripod can be fitted with wheels for use on smooth, flat surfaces. If you have an assistant to help, a wheelchair can make an extremely effective camcorder platform as you are pushed alongside your subject.

53

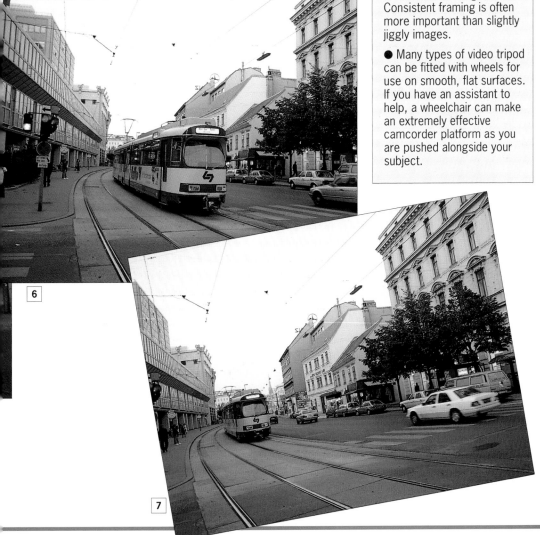

6

7

16 · Breaking up the action

One way of breaking up a piece of continuous action to create a more interesting sequence is to use cutaways. A cutaway is a shot of a specific detail inserted into a sequence, which either adds to our understanding of the action or is a reaction to what is happening in that sequence – a reaction cutaway. For example, in a sequence of a racecar turning a difficult corner, you could insert a piece of footage of spectators cheering – reacting to the action – before returning to the main sequence.

▶ Simple action

The value of using a cutaway can be seen in the sequence illustrated here. It would be perfectly all right simply to shoot this scene as a straight piece of action – a little boy eating a bowl of cereal in the back yard. However, by cutting partway through to a detailed shot of the bowl, hand, and spoon (frame 2), you immediately create a little additional interest. After the cutaway, the main sequence resumes. A cutaway such this could also be achieved in camera (see pp. 62-3), without having to edit the tape afterwards, because the action is so simple.

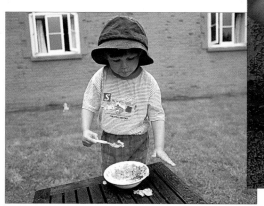

1

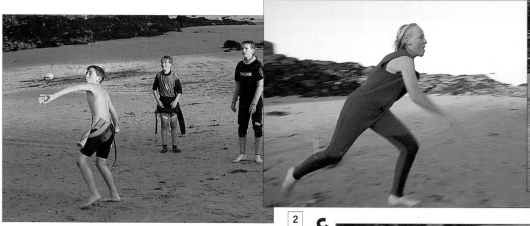

1 2 ↻

▲ Complex action

This action sequence has been broken down into a number of different shots to build a little dramatic interest. It opens traditionally with a long shot (frame 1) to establish the location. Here we see the ball about to be struck. Next we have a cutaway to a fielder (frame 2), before returning to the action (frame 3), but now framed a bit tighter. We stay with the main action (frame 4), but framed tighter still, before seeing a cutaway to another of the fielders (frame 5). Frame 6 takes us back to the main sequence, which finishes with another cutaway (frame 7) of a spectator lounging on the sand.

5

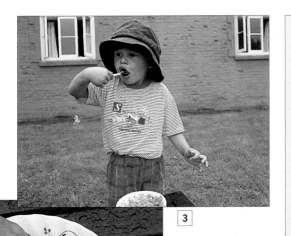

3

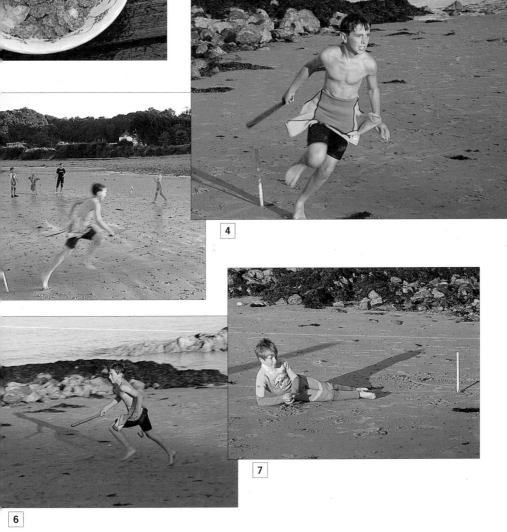

USEFUL TIPS

● If you don't want to edit your tape afterwards (*see pp. 154-55*), cutaways must be carefully planned at the time of shooting and used, generally, with simple action sequences.

● Unless your equipment offers video insert editing, inserting a cutaway, either at the time of shooting or as a part of the editing process, will destroy the sound continuity of the main sequence. You need to decide whether or not this matters.

● Although cutaways can add to the dramatic interest of your material, you need to exercise restraint when using them. If you are not careful, your results can look jerky and all sense of continuity may be lost.

55

4

7

6

17 • Handling action

In a scripted drama on television or at the movies, screen action is handled in a variety of ways, depending on what is to be conveyed – rapid cuts to indicate mounting tension or danger, perhaps, or leisurely paced scenes to imply the opposite. Even if you don't edit your tapes (*see pp. 154-55*), you can still vary shot lengths to evoke a particular atmosphere, use different shot sizes as a form of visual language, and select shooting angles to show the subject or setting in a surprising way.

▲ Dramatic perspective

This scene has been given added impact by the steep perspective of the shooting angle. In reality, you don't have four or five camcorders for one take and cut between them in the editing suite. You get only one chance, from one position, and you must try to capture it all.

56

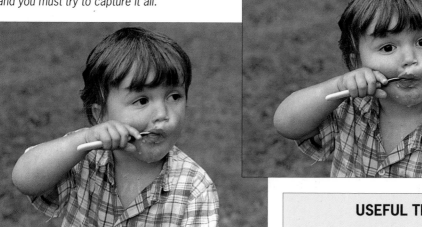

▲ Shot sizes for best effect

You can spoil the effect of action by using inappropriate shot sizes (see pp. 34-35). The broad categories of shot-size divisions can all be used to communicate different things to an audience. The close-up in the example above, for example, implies a relaxed intimacy between subject and audience, whereas moving in close still could seem like an intrusion into the subject's private space.

USEFUL TIPS

● If action is happening quickly, concentrate on recording everything you can in one continuous take. Only if time permits should you try to introduce a variety of different angles, shot sizes, and so on.

● Extreme close-ups of people's faces can be viewed by the audience as being confrontational and unnerving if held for too long.

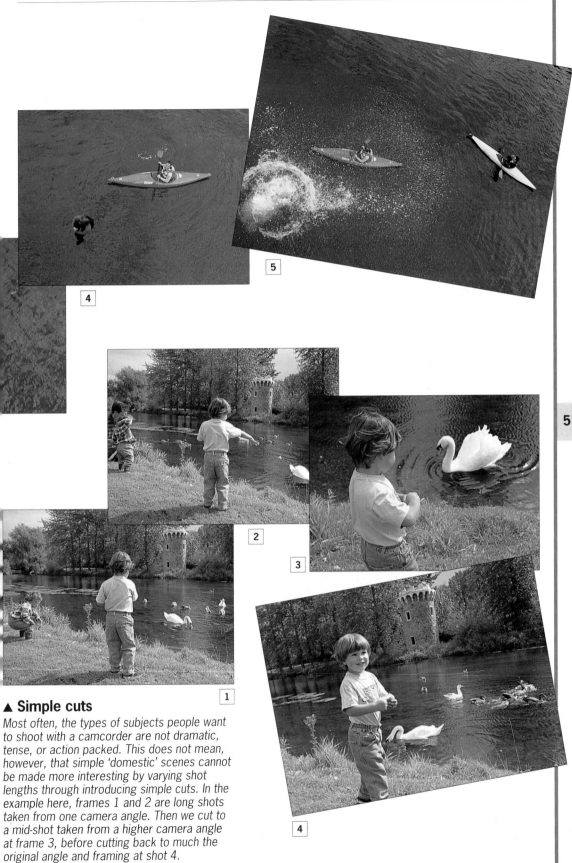

57

▲ Simple cuts

Most often, the types of subjects people want to shoot with a camcorder are not dramatic, tense, or action packed. This does not mean, however, that simple 'domestic' scenes cannot be made more interesting by varying shot lengths through introducing simple cuts. In the example here, frames 1 and 2 are long shots taken from one camera angle. Then we cut to a mid-shot taken from a higher camera angle at frame 3, before cutting back to much the original angle and framing at shot 4.

18 · Sound recording

The built-in microphone found on a typical camcorder is omnidirectional – it will pick up sound from all directions with equal sensitivity. Although in most situations this is fine, since your main audio interest will be to produce an 'atmospheric' soundtrack, specific sounds in the environment are likely to be lost in the background hubbub. On some camcorders you will find a high/low switch that gives you two levels of microphone sensitivity, but for truly selective sound recording you will need the type of external microphone (*see p.16*) that is sensitive to sound coming only from certain directions.

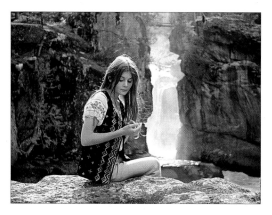

▲ Waterfall
In this situation the subject being taped is in a quiet, secluded place. The only sounds that could be picked up are the waterfall behind the subject and general bird song from all around. Here, the non-selectivity of a typical built-in microphone is exactly what you want.

▲ Beach playtime
The best type of microphone here depends on the soundtrack required. If you want sounds from the crowd of people behind the camcorder as well as the boys playing, the built-in microphone is fine. If you want to emphasize the boys' voices, then use a microphone with a forward-facing sensitivity pattern.

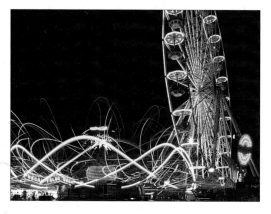

▲ Fairgrounds atmosphere
The soundtrack accompanying this type of scene consists of background noises of the music from the various rides and the distant babble of laughs and shrieks coming from the riders enjoying themselves. The omnidirectional sensitivity of a typical built-in microphone is exactly what you want to record the atmosphere of this occasion.

USEFUL TIPS

● Generally, you get better results when using an external microphone. This cuts down on motor noise coming from the camcorder itself as well as unwanted noises being made by the camcorder user.

● Unless you monitor the soundtrack as it is being recorded you will not be able to judge the quality of the audio portion of your tape until playback, and then it is often too late to make any corrections. Most camcorders come with a small earphone to allow you to listen to the sound as it is recorded, but a better option is using a pair of large stereo-type headphones.

● If the audio element of your tape is important, then bear in mind that every time you pause or stop your camcorder, you will, as a result, cause a break in the continuity of the soundtrack. Take this into consideration if you are planning to cut from scene to scene.

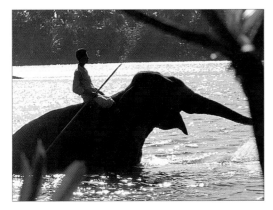

▲ Indian safari

The important audio element of this scene is the elephant's trumpeting and not the voices of your fellow tourists clustered all around you on the river bank. The very narrow, unidirectional sensitivity pattern of a 'shotgun' microphone would be ideal in this situation.

▲ Distant train whistle

An integral part of the audio-visual record of this scene is the general conversation of the different groups of families and friends waiting for the train (seen in the background), being made ready for boarding. The train whistle should not dominate, so an omnidirectional microphone is best here.

◄ Beach rhythm

Unless you used a microphone with a selective response pattern, it would be difficult to tell from this scene that the girl in white shorts is the subject of this shot. This type of microphone, known as a cardioid microphone, helps to eliminate extraneous noise. As a result, the song that she is singing while you are recording her is emphasized.

59

▶ Children shouting

These very noisy children are watching a puppet show on the beach. There is no concern here about picking out the voices of any particular children, and they are making enough noise to drown out background sounds, so a built-in omnidirectional microphone is just right.

19 · Continuity

The subject of continuity really only becomes relevant if you are planning to shoot some form of scripted action or sequence of events. Even in the most professional of productions, continuity errors sometimes occur – the window behind the characters is open in one shot, but closed in the next. This occurs because there may be days between the shooting of the two scenes, even though they are supposed to be part of the same time frame. When you shoot things as they happen, continuity is not an issue.

▶ Hat and boat

Even the simplest of home videos – a train ride in the country with the children, say – will make a more enjoyable tape to watch at some later date if you can see a complete sequence of events. For example, some footage of the family climbing out of the car at the train station, a scene shot on the platform, getting onto the train, and so on, is preferable to seeing the family climbing out of the car, followed abruptly by a discontinuous shot of them in the train. Doing things 'properly' really takes only a little bit of thought and planning, and part of that planning does involve being conscious of possible continuity errors (see below). In the top sequence here, the first shot (frame 1) shows a little boy moving toward a train station, wearing a hat and carrying a toy boat. In the next shots (frames 2 and 3), however, his hat and boat have mysteriously disappeared.

1

POSSIBLE CONTINUITY ERRORS

If you are shooting a proper dramatic sequence in which the continuity of even small detail is critical, one of the best ways of avoiding errors is to take an instant-picture photograph of your actors and the set before breaking off shooting for lunch or the day. When you resume, use the photograph as reference to make sure that your actors are all dressed exactly as they were and that all the props are in precisely the same places. Keep alert to the following possible continuity errors.

● A wall clock visible in one shot showing a time of, say, 2:00 and, in the next shot 3:30, even though only a few seconds are supposed to have elapsed between shots.

● Radically different lighting levels when cutting between two people having a conversation, caused by all the shots of one person being recorded at a different time than the shots of the other.

● A nearly empty wineglass being held by somebody in one shot, followed by another shot of that person with a full glass.

1

2

3

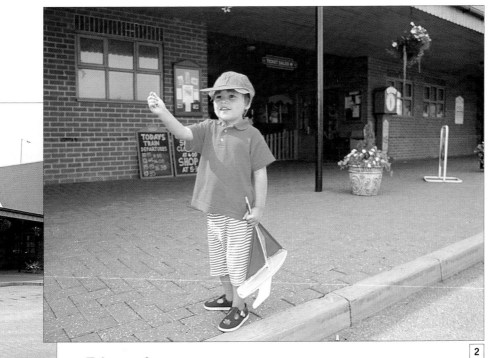

2

◄ Take two!

Having realized the continuity error described above, it took only a few seconds to shoot the scene again, and the action moves on to show the same little boy, now with his hat and boat, waiting outside the station.

20 • In-camera editing

If you don't intend to edit your tape (*see pp. 154-55*), then it is important that you plan your coverage before shooting so that it tells a coherent story. This is known as in-camera editing. Many people are put off by this idea in the mistaken belief that a detailed storyboard or shooting script is needed. For a full-fledged dramatic production, this may be so but, for most video situations, spending just a few minutes scribbling down ideas and reminders of things you must include is sufficient.

▶ Thinking ahead

This two-minute video sequence is presented here as it was shot. The scene opens with an establishing shot of young athletes waiting their turn on the track (frame 1) and then cuts to a close-up of an official announcing the start of the next race (frame 2). This allowed time to get to the side of the track to shoot a long shot of runners rounding a corner (frame 3), before cutting away for a reaction shot of the crowd (frame 4), and then quickly turning back to show the runners thundering past the camcorder position (frame 5). After that, it was a stroll to the awards area to record the winner of the race receiving his cup (frame 6). No postproduction editing was necessary and the footage from the camcorder tells a well-conceived, coherent story.

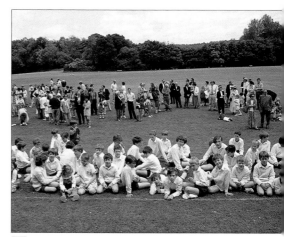

1

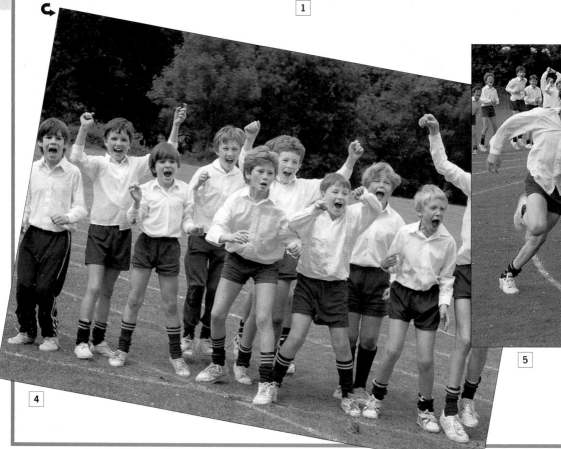

4

5

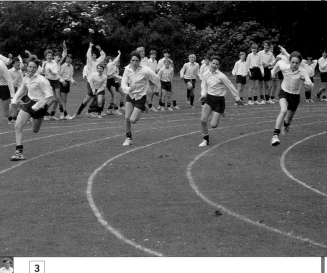

3

USEFUL TIPS

● Successful in-camera editing relies on keeping a clear idea of the narrative of the story as you record it. In the example on these pages, you could cut from frame 2 to a different race from the one being announced and it wouldn't matter to the audience. However, you couldn't cut from frame 4 to a race different from that shown at frame 3 unless you make sure that the audience won't be able to spot that the runners have changed.

● Remember to shoot bridging footage between scenes when doing in-camera editing. If you don't, then scene transitions may be too abrupt. If necessary, keep notes on a scrap of paper of the most recent scene you shot so that you will know if a cutaway is required.

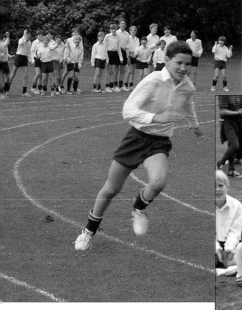

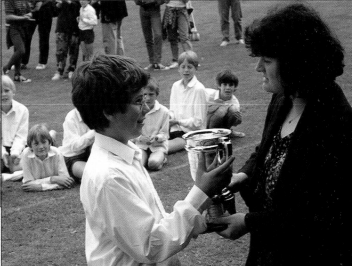

6

CHILDREN

Children are one of the most popular camcorder subjects. They change so quickly – seemingly from day to day – not only in physical appearance, but also in their likes and dislikes, activities and hobbies. This makes them the unendingly fascinating stars of many a family compilation tape.

'Ain't misbehaving'

Rather than being merely a passive observer of what is going on, the camcorder can sometimes initiate behavior and, thus, create situations that might not otherwise have occurred, especially where children are concerned. The simple sequence of images below is an amusing example of how this can happen. When this little boy realized that he was being taped, he started playing to the camcorder by doing things that were bound to get him noticed, and earned himself a mild rebuke for his pains.

1

2

3

66

▲ Harmless mischief

The chain of events recorded here started off in the kitchen, when this little boy's mother was idly taping him while he sat at the table, about to have his drink. As soon as he realized that the camcorder was pointing in his direction, however, he mischievously began inching his hands toward the glass. It was obvious to his mother that something worth recording was going to happen, so she continued taping. By zooming back from the extreme close-up of his hands to a normal close-up, the lens was then able to take in his face and hand as he plunged it into the bottom of his glass. This particular sequence ends when his father notices what is going on and tells him to drink properly. Although the father is not in the shot, his voice is clearly picked by the camcorder's built-in microphone. The soundtrack therefore ties in well with the little boy turning his face in his father's direction and grinning broadly.

7

▲ All is forgiven

The second sequence of this domestic scene ends happily with the little boy responding to his father's admonishment, finishing his drink properly, and then trying to squeeze his face into the now empty glass. The whole screen time for these two sequences is less than a minute and the only camcorder movements required from frame 3 onward were motivated by the need to keep the subject centered in the frame.

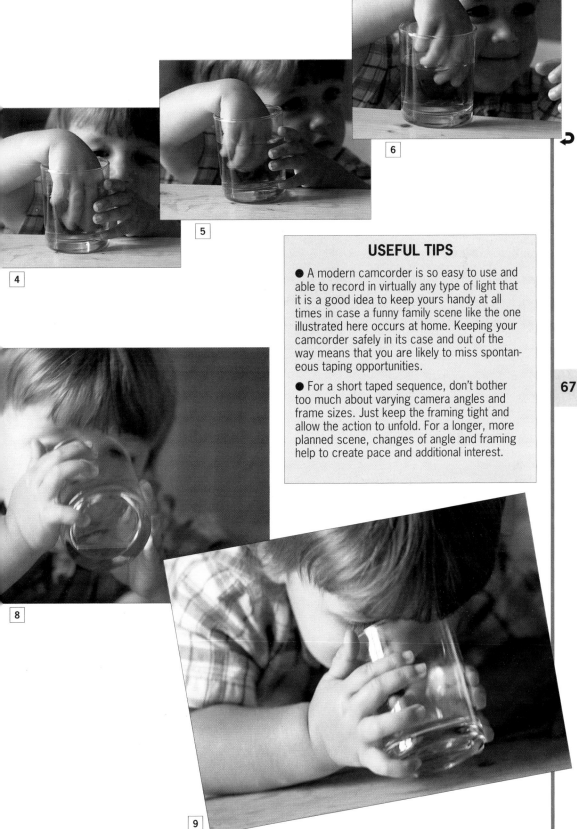

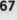

USEFUL TIPS

● A modern camcorder is so easy to use and able to record in virtually any type of light that it is a good idea to keep yours handy at all times in case a funny family scene like the one illustrated here occurs at home. Keeping your camcorder safely in its case and out of the way means that you are likely to miss spontaneous taping opportunities.

● For a short taped sequence, don't bother too much about varying camera angles and frame sizes. Just keep the framing tight and allow the action to unfold. For a longer, more planned scene, changes of angle and framing help to create pace and additional interest.

A day out with the children

A 5- to 10-minute video presentation of a day out with the children can be handled in two ways. First, it can be a confusing and haphazard collection of unconnected shots that requires constant explanation and interruption; or second, you can make a mini-production consisting of, say, half a dozen main, thought-out sequences that come together to tell their own story. If you don't want to undertake any editing after shooting the tape, then some degree of planning is essential.

▶ Developing the story

Every tale needs a beginning, and so this story of a day out with the children begins with a shot of the kids in the car, pretending to drive. Next we see them arriving at the train station and the older child walking back from the ticket office after having found out the time of the next train. The camcorder is stationary throughout shots 3, 4, and 5, and the autofocus is well able to cope with the boy as he walks toward the camera position.

68

▶ A change of subject

The star of this sequence of shots is definitely the train. Two carefully thought-out camera positions give the audience a good view of the cars, and the people on the platform waiting to board, as well as the brightly painted locomotive itself. To ease the transition into the next sequence, the final shot here shows the children, a little reluctantly, being hauled aboard the car.

▲ Potential cutaway

As a transition between different sequences, here the close-up of the boy at frame 5 and the long shot of the train at frame 7, you could use a cutaway. The one above shows the older boy once more in the shot, but now standing on the platform of a stationary locomotive waiting at the platform.

▶ Waiting to be off

Now that the family is aboard, the camcorder is passed around a little so that both parents can be seen in at least some of the shots. Don't forget you also have a soundtrack – the final shot in this sequence has the train whistle blowing, signaling the journey's start.

A DAY OUT WITH THE CHILDREN

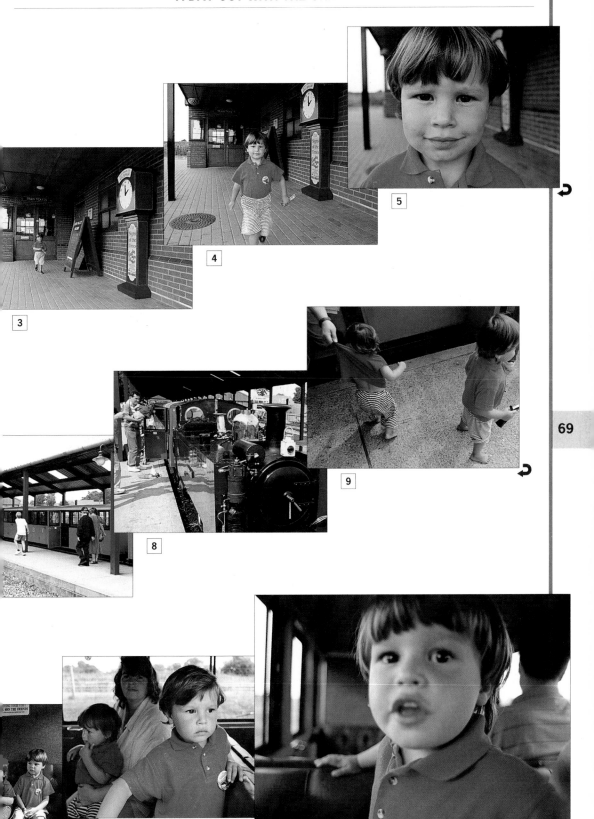

◀ Inserting a sequence

If you want to use a sequence such as this, of the train you are traveling on emerging from a tunnel and moving past your camera position, you will have to record it out of sync with the rest of the story and edit it in afterwards (see pp. 154-55). Although it is not essential to the story-telling, it does provide a welcome change of pace and it also adds to the professionalism of your tape.

13

14

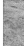

15

▶ Concluding sequence

As the journey progresses, make sure you include footage of events happening inside the car and also of the world beyond the windows, such as the landscape you are traveling through and the lucky shot of an oncoming train. If you all want to be to-gether in some shots, then you will have to enlist the help of another person to shoot some of the tape – perhaps the train's conductor. A shot of the train slowing to a stop at the platform, followed by the family getting ready to disembark, lead up to a naturally concluding mid-shot of one of the children being rewarded with a popsicle.

21

22

23

USEFUL TIPS

● To avoid having to edit the tape afterwards, make a simple storyboard – a drawn or written plan – outlining how you are going to tape different sequences, move the action on from location to location, and how you will conclude the story. Even if events occur that prevent you from following the storyboard step by step, at least you will be sensitive to the needs of the storyline and you can then adapt the tape's progression as necessary to suit the changed circumstances.

● Sounds, such as the approaching train at frame 18, will have more impact if they are accompanied by a visual record of what made it. This is the type of event you can't predict in advance when planning your coverage.

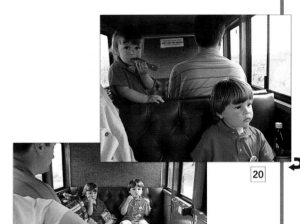

20

19

18

17

71

25

26

27

Family picnic

With the best intentions in the world, nobody wants to sit through a blow-by-blow, real-time recording of an entire picnic. The idea here is to produce a three-minute tape that everybody will enjoy looking back on in years to come. Your coverage should include some wide shots showing all of the participants – when everybody is seated and eating is probably best for this – as well as some individual mid-shots and close-ups. Work some good angles of the setting into the tape, too, if they are attractive.

▼ Introducing the characters

The function of these first few shots is to introduce the cast of characters present at the picnic. Although the general advice is to start in a wide shot to establish the location of a scene, here we see the two children in mid-shot initially and then we cut to a wider-angle view at frame 2 to encompass the setting and then a wider-still view at frame 3, which has been taken from more of an overhead camera position.

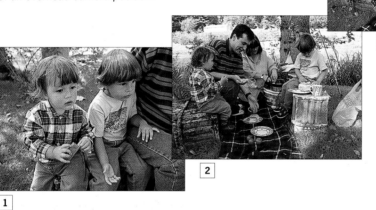

▼ Involving the camcorder user

Having moved in closer to the picnic spread at frame 4, still from the overhead vantage point, we can now see the younger child studying a caterpillar on his father's hand. The action next cuts to the other child, who is playing host by offering a piece of cake to the camcorder user. A slight reorientation was needed to center the child in the frame.

72

▶ Manipulating the action

This type of family video coverage is very informal and so you should not feel inhibited if you, as the camcorder operator, want to intervene in order to manipulate the action and become part of the coverage itself. This shot came about when the camcorder operator called out the child's name (which made him spin around) and then taped his laughing reaction to being surprised. The shots before the one here showed the boy with his back to the camcorder.

8

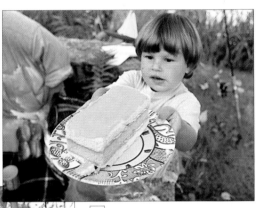

7

USEFUL TIPS

● Don't ignore the background while taping. Often all it takes is a slight change in vantage point to frame your subject against a pleasing, positive background.

● The change of pace resulting from a mixture of candid images and others, where the participants are responding directly to the camcorder, is always welcome.

73

11

10

9

◀ Action out of range

Although only a short tape overall, you can see from the selected frames on these pages that it has been pretty carefully structured so that both children are given approximately equal coverage. In this sequence, we see the younger child reacting to something that has happened out of range. When this type of situation arises, you then have to make the decision whether or not to pan or cut to that off-camera action and include it, too. When using a camcorder, you will often wish you could be looking in two different directions at once.

Gone fishing

Low-activity events and hobbies, such as fishing, can be difficult to record in an interesting fashion. You will need to think carefully about how the audience will react to your coverage, so you should try to show a good mixture of different-length sequences (to vary the tape's pace) and plenty of changes of camcorder vantage point, too. As well, stay alert to the need to show variety in your choice of framing – close-ups, mid-shots, and long shots (*see pp. 34-35*).

▶ Using a good setting

When you have a setting as attractive as this lovely lake in full sunshine, allow your opening wide-angle shot take as much of it in as possible. If your reactions are quick enough, you could start this sequence off by slowly panning over the water, taking in the lilies and ducks, and come to rest on a long shot of your characters – here, two little boys out with their father for a day's fishing. In fact, it is not until this sequence progresses a little that we see the second of the children – he has lagged behind the camcorder position and when he runs into view (frame 2) to catch up, we see his father turn and squat down to encourage him along (frames 2 and 3). Then they all turn again and resume their search for the best fishing spot (frame 4).

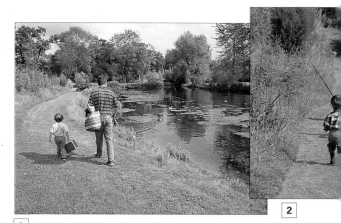

1

2

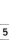

5

◀ Changing the vantage point

For the next sequence, the camcorder has been positioned in front of the trio so that the audience can see them continuing their walk, face-on to the camcorder, adjacent to the lakeside, which is just out of sight on the extreme left of the frame, behind the line of trees. This shift in the camcorder's point of view is easy to achieve and represents a professional flourish. To finish off this sequence, allow the subjects to walk past the camcorder and out of range.

3

4

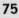

7

8

▲ Changing framing

An intervening sequence shows the fishing tackle being set up by the boys' father and the rod being passed over to the older child. Coverage here resumes with a carefully composed long shot taking in the boy standing on a stone wall to give him the extra height he needs to reach the water with his line over the intervening undergrowth. The background works well here, as does the view of the toy boats behind. In the final shot of this sequence (frame 9) I cut to a mid-shot, which reveals more of the boy's expression.

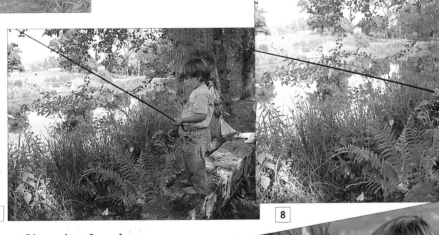

9

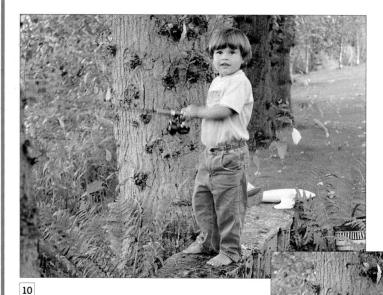

10

▲ The drama unfolds

Squeals of excitement and delight from the youngster, which are clearly audible on the soundtrack, accompany this change of vantage point and framing. Here we have cut from the previous mid-shot (frame 9 on the previous page) to a long shot (frame 10). The rod is quivering and jerking slightly, and all the signs are that a fish has been hooked. A zoom-in to a mid-shot is called for here (frame 11) so that the audience can more clearly see the boy's reactions. Ideally, a cut to the water to see the fish (or the disturbed water where the fish would be) would have been logical at this point, but the undergrowth at the water's edge at this part of the lake didn't make that a feasible option.

11

13

12

USEFUL TIPS

● If your subject is positioned in the shade, try to find a position to shoot from that excludes any very bright highlights in the rest of the scene in the viewfinder. In this way you will minimize contrast levels and so help to avoid potential exposure problems.

● When cutting from scene to scene, make sure that you don't cut from mid-shot to mid-shot, close-up to close-up, or long shot to long shot of the same subject. If you do, it will look to the audience as if a mistake has occurred and that a piece of the action has been cut out. This type of error is known as a jump cut.

15

14

◄ It all turns to tears

In the final sequence of shots from this fishing expedition we can see, and hear, that the fish has slipped the hook and swum away. The scene is framed throughout in close-up (frames 12, 13, and 14), moving into a bigger close-up (frame 15) for the finale. Depending on your point of view, you could think that the trip was a bit of a disappointment. From the fish's perspective, however, it was the perfect outcome.

Children's expressions

One of the best things about taping children is that they very quickly forget about you being there and revert to their uninhibited selves, especially if they are with their friends. However, if you really want to keep to the sidelines, and so avoid perhaps influencing your subject's behavior, use the lens zoom control on its longest setting. In this way, you should then be able to keep back from the action and still frame the subject in close-up or mid-shot.

▼ A natural performer

I noticed this little girl in a crowd of children at a school party. There was plenty of activity all around – face-painting artists, sideshows, rides, booths, and so on. But what initially caught my eye was the purple-pink color harmony of the clothes being worn by all the kids in her little group. Moving physically close to the subject would have been a mistake in this situation on two counts. First, the children would have become aware of the presence of the camcorder and I wanted these images to be totally candid right from the outset. Second, there were so many other children in the immediate vicinity, I would inevitably have blocked the view of some of them and probably would have been jostled as a result. As it was, I shot from a slightly elevated bench seat on the periphery of the crowd and was able to record an unobstructed view of her amazing repertoire of facial expressions. She was so entertaining that this sequence alone could easily have taken up 20 seconds of screen time – quite long in the context of a 5-minute tape of the whole of the afternoon's events.

2

1

3

USEFUL TIPS

● When you set up a shot with a largely stationary single person as the main subject, it is important that you keep the shot framed in such a way that the person occupies approximately the same area of the screen throughout.

● If part of the interest of a shot is based on the arrangement of the colors that can be seen, keep the framing tight enough to prevent unwanted colors from intruding and spoiling the overall effect.

● Use a tripod whenever possible in order to produce rock-solid pictures.

5

4

Playing to the camcorder

As well as recording candid moments with the children (*see pp. 78-79*), the camcorder is also a very valuable tool when you want to make a more formal recording of children's activities. In the example here, you can see clearly, step by step, a face painter at work transforming a normal young girl into a fanged monster. It took about 15 minutes to bring about the complete transformation, but this could easily be compressed into 3 or 4 minutes without losing any important visual information.

80

▼ Step-by-step coverage

This type of tape can work on two levels. First, it would be great to have something like this just as a family record of your child being made up for a party and, second, it also works as an extremely useful teaching aid for anybody interested in trying his or her hand at face painting. If you talk to the face painter first, you will be able to work out exactly the sequence of events you will need to shoot for complete, but not overlong, coverage.

<table>
<tr><td>

USEFUL TIPS

● For a rock-solid recording, mount the camcorder on a tripod and work out the best camera position to show the face painting in the most revealing detail.

● The ideal soundtrack for this type of scene would be the face painter describing the process and exactly what she is doing at every stage. If necessary, the camcorder operator could prompt the artist by asking specific questions.

</td></tr>
</table>

4

5

81

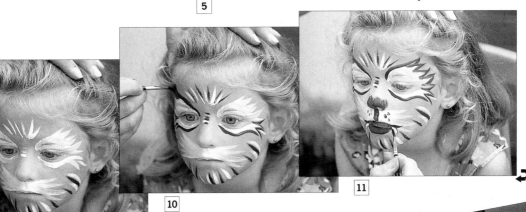

10

11

▶ Gallery of faces

Although the step-by-step coverage shows only one child being made up, this shot represents a short sequence at the end of the tape displaying just a few of the other types of face-painting styles that can be achieved. This is also the only part of the tape where we get to see the face painter herself. A video such as this would make an ideal promotional tape for a face painter, and then you could run captions at the end, giving relevant details.

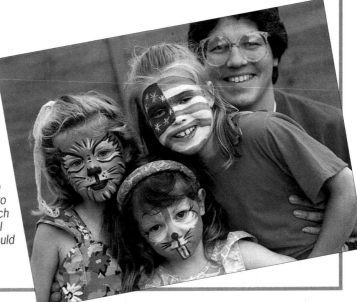

Bedtime story

Because of the busy lives we tend to lead, the times during the day that we set aside to devote just to the children are extremely important. One of the daily rituals that all children (and parents) seem to enjoy is the bedtime story. To make a video record of this for your family archive, be realistic about the attention span of its potential audience – family and close friends – and plan in advance for about a five-minute reading. A complete mini story or chapter will make for a better soundtrack.

▶ 'Fly-on-the-wall' treatment

For this type of recording it is important that the camcorder draw as little attention to itself as possible so that all attention is fixed solely on the participants. This means keeping changes of shooting position, framing, and so on to a bare minimum. The opening establishing wide shot in this sequence was taken as the mother and child were still settling into their storytelling routine. Then, a slight shift of camcorder position to the right and a zoom-in to a comfortably close, intimate two-shot was all that was necessary for the rest of the tape. Too much movement of the camcorder operator is bound to be distracting and is likely to spoil the atmosphere of the scene.

82 ↻

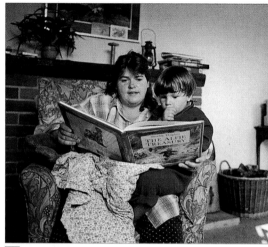

1

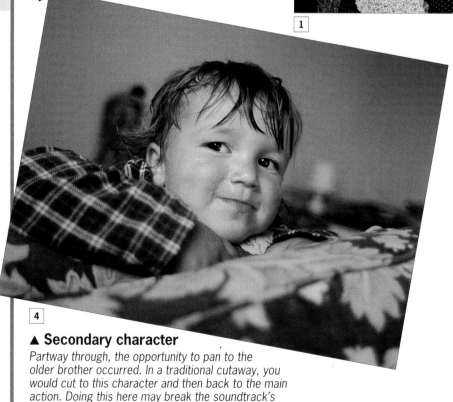

4

▲ Secondary character

Partway through, the opportunity to pan to the older brother occurred. In a traditional cutaway, you would cut to this character and then back to the main action. Doing this here may break the soundtrack's continuity. The advisability of this pan is a creative decision you need to make at the time.

5

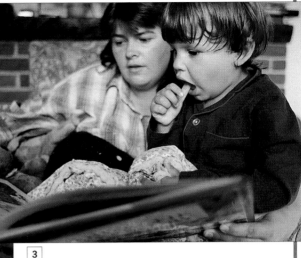

3

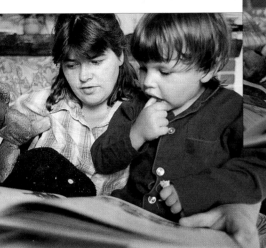

2

USEFUL TIP

● Record this type of video when there is plenty of natural light in the room. Introducing artificial light would be relatively easy, but it might also prove intrusive. If contrast is a problem, position white posterboard reflectors on the shadow side of the subjects to reflect extra light.

83

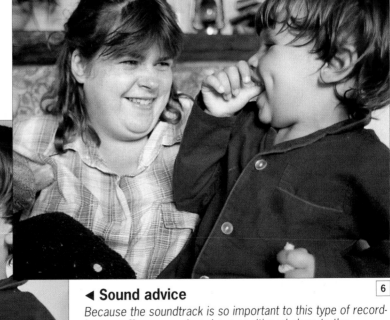

6

◀ Sound advice

Because the soundtrack is so important to this type of recording, an off-camera microphone positioned close to the subjects would be ideal (see p.16). Taking the microphone off the camcorder lessens the chance of motor noise intruding, and positioning it close to the subjects also makes it less likely that noises from the rest of the house, or from outside, will be picked up. Since this sequence was taped from the far side of the room, the mother's quiet reading voice might not have been clear with a microphone on the camcorder.

Bath time

Like the bedtime story (*see pp. 82-83*) bath time is one of those family rituals that parents like to make an occasional recording of. Children change so quickly at around the age of the young subjects here that, unless some record is made of them, many wonderful memories may be lost for ever. Continuity of the soundtrack accompanying a sequence like the one below will probably not be particularly vital, and this gives you more opportunity to cut between different camera angles and framings.

1

2

▲ Bath-time fun

Because this bathroom was quite small, most of this sequence of shots was taken with the lens zoomed back toward the wide-angle end of its range. If you were to frame the children too tightly, you could easily be caught off guard as they darted back and forth in the bath, and this would mean

swinging the camcorder about in an attempt to keep up with them. This type of unplanned camera movement looks amateurish on screen and can be uncomfortable to watch, making the audience feel a little seasick. Talk to the children if you like and attempt to get them to respond to the camcorder.

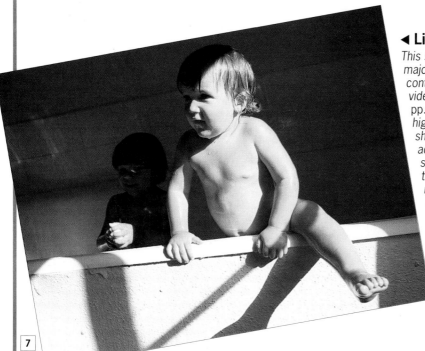

7

◄ Lighting contrast

This shot illustrates one of the major problems you have to contend with when shooting video – lighting contrast (see pp. 30-31). Adjacent bright highlights and deep shadows cannot both be accommodated at the same exposure. In fact, the contrast here has resulted in an attractively dramatic shot – too little contrast can make the results dull and uninteresting – but one of the children has practically disappeared in the deep shadows.

6

5

4

85

USEFUL TIPS

● When you are using reflective surfaces, such as mirrors, as a part of the scene being recorded, make sure your own image does not appear in the shot accidentally.

● Filtering the light entering the bathroom through a thin window shade helps to minimize contrast problems caused by harsh daylight.

9

8

▲ A different angle

One way of introducing a new angle on the coverage in this particular bathroom was to shoot the image reflected in the wall-mounted mirror of the little boy's father scooping him up in a towel and drying him off. This proved to be an excellent way to record what was going on without having to intrude on the situation by asking them to turn around and face the lens.

10

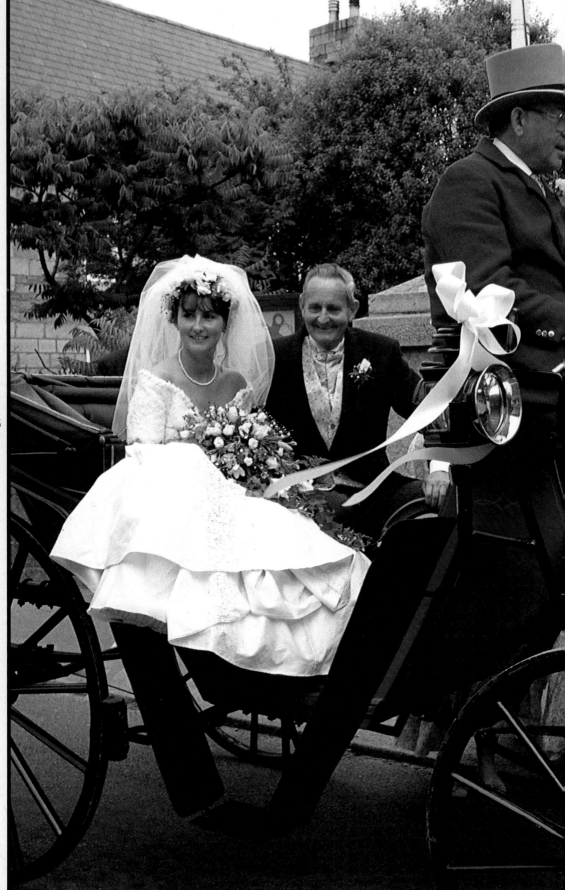

WEDDINGS

Although no two weddings are alike, by adopting the right approach and planning your shots in advance you will be able to adapt the information in this chapter and make a wedding tape that the happy couple will look back on with pleasure in years to come.

A traditional wedding

This chapter of the book deals with one potential way to video a traditional church wedding. But no matter what type of wedding it is, you can use the examples here as a sort of template, adapting them as necessary to the particular circumstances of the one you are involved in. Bear in mind that all types of wedding follow a fixed agenda, and that by planning your coverage in advance you will be able to break it down into a series of set pieces, all of which you will need to include for complete coverage.

▶ Setting the scene

Rather than jumping straight into the action, a wedding video often works best by starting off slowly and gradually building to a crescendo of activity. This coverage starts off traditionally, by setting the scene with some external shots of the church. This is a fine old church, beautifully decorated with hanging baskets of brightly colored flowers, and is a positive asset to the tape. If scheduling this time is difficult, you could shoot this type of material on the day before the wedding to give yourself less to do. If so, then the light on both days will, ideally, need to be consistent.

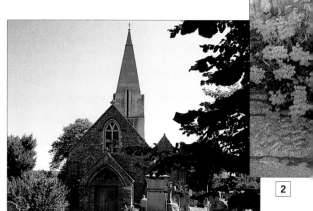

1

2

88

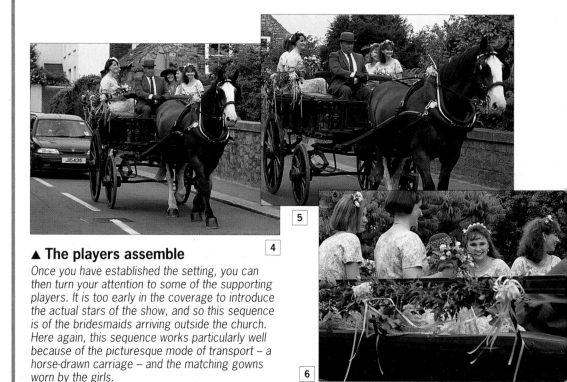

5

4

▲ The players assemble

Once you have established the setting, you can then turn your attention to some of the supporting players. It is too early in the coverage to introduce the actual stars of the show, and so this sequence is of the bridesmaids arriving outside the church. Here again, this sequence works particularly well because of the picturesque mode of transport – a horse-drawn carriage – and the matching gowns worn by the girls.

6

3

USEFUL TIPS

● If you are going to be taking the official videotape of the wedding, talk to the bride and groom well before their wedding day to find out the type of video treatment they would like. Coverage could start at the bride's home, for example, with her leaving it for the last time as a single woman.

● In consultation with the couple, draw up a comprehensive shot list so that you know exactly who they particularly want to be included on the tape. If you don't know these people by sight, make sure a family friend will be available to assist you in finding them on the day.

● In advance of the wedding day, speak to the minister, or the person officiating at the ceremony, and find out if you will be allowed to tape inside during the wedding, and if you can use supplementary lighting.

● Carefully scout the location before the wedding day to find the likeliest shooting positions for the different parts of the coverage – both inside and outside the church. If you are to tape the reception, too, survey that as well.

◀ Introducing the groom

It is usual for the groom to wait anxiously outside for a little while, supported by his best man (frame 7), and it is expected that his tormented last few minutes as a bachelor be recorded for posterity (frame 8). This sequence of shots has been set up using the church doorway as a background, and it was also a good opportunity to include not only the best man but also the formally attired ushers. Camcorders are now so common that it is almost inevitable that at least some of the guests at any wedding will be using them. The final shot of this sequence (frame 9) shows one of the guests using his.

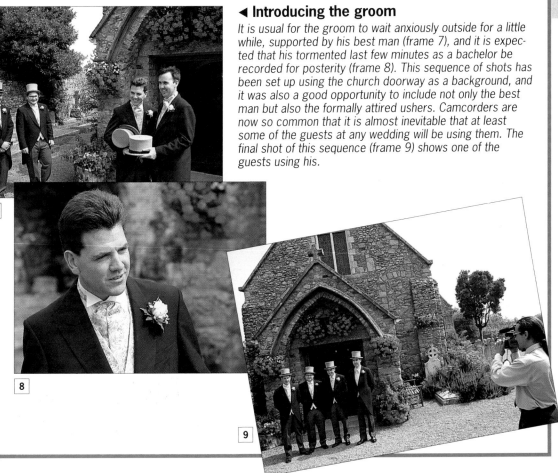

8

9

Once the guests start to arrive, you will be shooting nonstop until the bride's entrance. This is when you will appreciate the planning you did with the couple when you met them before their wedding day – sorting out the people who are essential to record. As more and more of the guests arrive, it is important that you keep in mind the overall structure of the wedding tape. As well as recording footage of individual guests, look out for interesting groupings of people, such as families congregating together, the bridesmaids and ushers, and so on. Informal groups will be forming anyway, and you can take advantage of the work being done by the official still photographer by making a video recording of the formal groups.

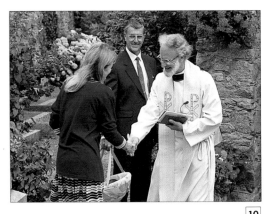

10

1

▲ Minister and guests

Certain of the players at a wedding are a natural magnet, drawing to them a good sample of all the people attending. The minister is one of these, and so it is a good idea to concentrate at least some of your time taping him as he greets the guests arriving. Choose your camcorder position carefully to make best use of good backgrounds and lighting.

▲ Individual faces

This footage (frames 11 and 12) is very useful. When this guest realizes she is being recorded, she breaks into a broad smile. When assembling the finished tape, material like this can be used as a reaction cutaway within another sequence.

14

1

16

▲ Ring bearer

Having seen the ring bearer in the previous sequence (frame 13), you have a natural cutting point to a close-up sequence of the same child, looking a little apprehensive in his top hat and bow tie, before moving onto a mid-shot of him with his mother and father (frame 15) and semi long shot also taking in his baby brother in a carrier (frame 16).

90

▶ Formal groupings

This group (frame 13), consisting of the bridesmaids and the bride's mother, has come together so that guests can take some photographs. But it is also an excellent opportunity for you to record them for your videotape. Look out, too, for cutting points – the ring bearer here is a link with the next sequence (frame 14).

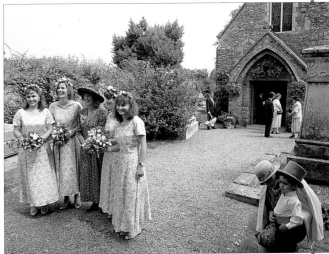

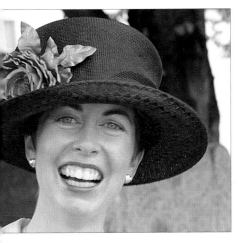

13

91

▼ Associated imagery

The baby in the previous sequence (frame 16), seen in long shot, links to this image of another child of about the same age (frame 17), which is the first image in a tilt sequence that finished in a mid-shot looking past the back of the father's head into the faces of the people he is talking to.

18

▲ Interactions

Weddings are a complicated set of social interactions, all of which can make fascinating and enjoyable video coverage for those involved. Now we see and hear the bridesmaids and ushers excitedly discussing the bride's imminent arrival.

17

▶ Mounting excitement

The soundtrack accompanying the previous sequence (frame 18), with the bridesmaids and ushers announcing that the bride's carriage is in sight, motivates this next cut. It is important not to play your trump card too early, and here the video coverage lets the excitement build by showing only the backs of some of the guests straining to catch the first glimpse of the bride.

19

Some aspects of the wedding day are so important that you must make absolutely certain you cover them fully. One of these is the arrival of the bride and her father outside the church, as well as their progression into the building, culminating in the wedding ceremony itself. Although there are bound to be some guests outside the church, waiting to glimpse the carriage's arrival, the ushers should by now have ensured that nearly everybody is inside and seated, so you will have a pretty clear field to shoot your tape. Since this material is so critical, shoot more footage than you think you will need. Timing is also important; you have to get yourself and your equipment inside the church before the ceremony begins in order not to cause a disturbance.

▼ The bride arrives

This sequence of the bride and her father arriving by horse-drawn carriage is absolutely crucial to the tape and you should plan your shooting position well in advance. It starts off in mid-shot (frames 20 and 21) before cutting to a long shot of the bridesmaids fussing around their charge and arranging the bride's gown (frames 22 and 23). Time will now become increasingly important, since you don't want to leave the groom standing by himself at the altar for too long waiting for his bride.

92

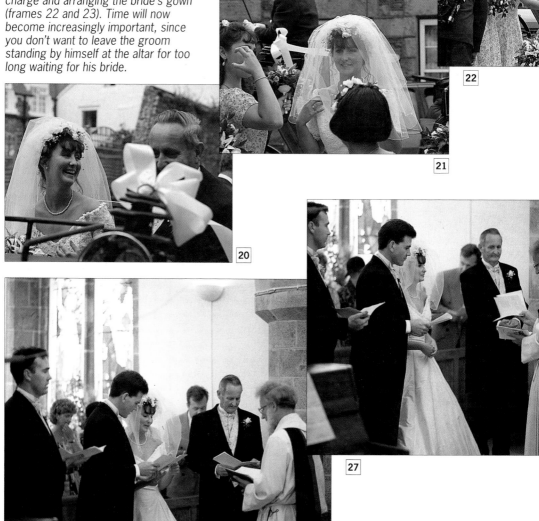

23

24

▶ Set piece

A final straightening of the bridal gown's hem and the bridesmaid is finally through (frame 24). Now father and daughter are ready for one of the principal set pieces of the day – a posed sequence of them together outside the church door (frames 24 and 25). Although you will be under pressure here, concentrate on all aspects of framing, including the background.

25

93

28

◀ The ceremony

Get inside and into your pre-arranged shooting position quickly and quietly. You will have to shoot most of the ceremony from one fixed camera position, since any pause in the visuals as you change to another angle will also cause a break in the soundtrack. Vary framing using the zoom, but don't overdo it (see pp. 44-45.) An opportunity for a change in shooting position in this service occurs between the ceremony itself (frames 26 and 27) and the blessing (frame 28).

The material shot outside the church before the wedding is, in the main, semi-candid footage. An element of this approach persists after the wedding ceremony, too – so be alert to any spontaneous shooting opportunities that may present themselves – but at this stage of the proceedings everybody is expecting to form themselves into the formal, set-piece groupings that follow the service. As always, there will be time constraints. The carriages and drivers are parked outside waiting for the main participants, the caterers are waiting at the reception, and everybody is eager to be off to the party. If there is an official still photographer, pool your resources and organize and shoot these set pieces together.

◄ The key shot

This is one of the key dramatic shots of this part of the activities, so why not play up its dramatic possibilities? Get outside and set up before the church doors open. As they do, the music and noise from inside will well up, which is great for the sound-track, and slowly the bride's stark-white gown will begin to emerge from the heavily shadowed interior.

29

▶ The shot list

This is when you will again appreciate the shot list you drew up before the wedding day. It is important to work quickly at this stage – take too long to organize these set pieces and you will find that some of the key players have wandered off, and while they are being tracked down you will lose yet others of your party. Almost always, there will be an official photographer present. Why not combine your resources and organize these group shots together, and then take turns recording the results? You will both have much the same requirements in terms of lighting direction, backgrounds, and so on.

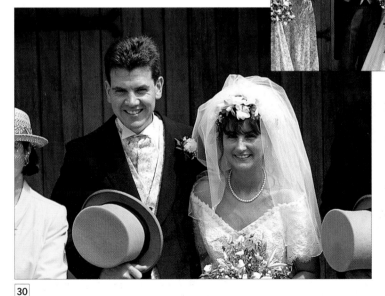

30

EQUIPMENT CHECKLIST

- Camcorder with fully charged batteries.
- Ample spare battery packs, fully charged.
- At least 50-percent more tape than you think you will shoot.
- Fully charged battery-powered video light.
- Spare batteries and bulbs for video light.
- Off-camera microphone and extension cord (optional).
- Tripod and (optional) monopod.
- A selection of special-effects filters, such as starburst and haze, for occasional use.

33

32

31

35

34

With the more formal wedding group shots now 'in the can' (*see pp. 94-95*), much of the tension everybody was feeling has been released and the video coverage once more reverts to more 'grabbed,' informal sequences. Your main considerations at this stage are to record the rice- or confetti-throwing ritual, which everybody enjoys and which always looks good on screen, as well as the bride and groom departing for the reception. If you are lucky, you should be able to accommodate these important sequences using just two camcorder positions, as you can see from the shots illustrated here. If you are to cover the reception, too, then you will have to gather your equipment together quickly in order to reach the venue before the wedding couple.

▶ First shooting position

By installing the camcorder directly outside the gates of the churchyard, it was possible to shoot this exciting part of the proceedings in one continuous take. The rice or confetti raining down on the couple and everybody jumping up and down are bound to obscure your view for parts of the take, but this just adds to the atmosphere.

36

37

96

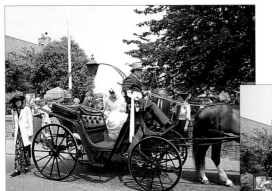

41

▲ Second shooting position

A quick change of camcorder position, now on the far side of the horse-drawn carriage, allowed this final sequence also to be shot as a single continuous take. Before starting to shoot, however, make sure that no rice or confetti has stuck to the lens. Most of this sequence was shot with the lens zoomed back toward the wide-angle end of its range. This allowed a sufficiently wide angle of view to encompass the entire carriage as well as the guests milling about on the periphery of the scene. As the bride and groom settled down in the carriage before setting off, the lens was zoomed in a little to give a more tightly framed shot, finishing in an attractively framed two-shot of the happy couple looking directly at the camcorder.

42

43

38

39

40

97

45

44

SUGGESTED SHOT LIST

- Establishing shots of church.
- Groom and best man before ceremony.
- Informal shots of guests outside church.
- Bridesmaids and bride and father arriving.
- The ceremony itself.
- Newlyweds after ceremony.
- Newlyweds with ushers and bridesmaids.
- Newlyweds with parents and with friends.
- Rice and confetti throwing.
- Newlyweds departing for reception.

VACATIONS

While on vacation, most us have more free time than usual to put together a tape. Not only is it the perfect opportunity to put into practice many of the techniques described in this book and sharpen your video skills, but you will also end up with a superb record of your travels to look back on and enjoy.

Setting the scene

An integral part of your vacation will be the hotel you stayed in and your favorite bars and restaurants. Bear in mind that the audience for your vacation tape may include people who weren't with you, and they will enjoy seeing as many different aspects of your location as possible. These sequences don't have to be long – even 5 to 10 seconds of screen time showing interesting views of your hotel may help smooth out the bumps in the coverage before showing any interior shots.

▶ The telling angle

Resist the temptation to lift the camcorder to your eye and start taping before you have spent a little time looking for the most ef-fective angle from which to shoot (see pp. 32-33). In this selection of views of a small hotel on the coast of Jersey, an island off the coast of England, you can readily see that some approaches work better than others. Frame 1 shows the hotel in close-up. The shooting position from across the narrow street gives a cluttered impression of parked cars and an unsatisfac-tory framing of the building itself. Frame 2 is an improvement – unusual shooting angles are often eye-catching. Frame 3 is stronger, with seemingly converging lines drawing the eye into the frame and toward the hotel. Frame 4 makes an excellent establishing shot, and the use of contrast adds a dramatic note. However, the most telling treatment is frame 5, which shows a picturesque castle looming over the entire scene.

100

1

2

2

◀ Moving inside

When moving inside to tape, your camcorder should automatically adjust its white-balance control to take account of the different color temperature of the light. In this short sequence, the opening frame is of the interior of a small, family-run restaurant. The camcorder then pans before coming to rest on one of the camcorder operator's friends sitting at his regular table near the window. if you want candid-looking sequences, pretend you are taping the person sitting opposite you at your table.

1

3

4

USEFUL TIPS

● Before leaving your hotel, make sure your camcorder batteries are fully charged and that you have plenty of spare tapes with you.

● Use local tourist-information centers to find the most interesting locations for shooting.

5

◄ Character shots

Some modern camcorders are so small and unobtrusive that you can carry them with you anywhere you go – even into bars for a quiet drink when you are taking a break from sightseeing. Don't miss an opportunity to record any interesting characters you might see at times like this, such as this elderly lady cuddling her dog at one of the tables. Obviously this is not a candid shot, and so it is good manners to obtain the subject's permission before beginning to tape.

Local color

When you go on vacation to a new locale in your own country or, even more so, in another country, it tends to be the small things that initially jump out at you as being different. It might be the style of the clothes people wear, the colors of the houses, street signs, window displays, or an almost indefinable difference in the 'pace' of the city – the flow of pedestrians and cars, for example. Recording these elements of local color will help to give your video coverage added impact and atmosphere.

▶ Tribal identity

It is common in parts of Africa, and in other parts of the world where tribal life still survives, for groups to have distinctive styles and colors of dress, jewelry, and so on. These modes of dress and ornamentation can be sufficiently fixed to form part of a tribe's identity. A close-up framed like the one here is perfect to show the wonderful blues and blacks of the woman's clothes and the rich gold of her accessories. At the same time, the framing shows enough of the textural background to make a positive contribution to the composition as a whole.

▶ Details matter

A vital part of local color is the wealth of small things, the myriad details that you would not normally see at home. The styles of storefronts and signs are some of the obvious things you will probably notice, since these tend to be very culturally specific. Enormous hand-painted billboards advertising the latest movie releases are also common in much of Asia. These are often very beautiful creations, yet they are torn down and changed every few weeks.

▼ National costumes

The wearing of national costumes in most countries today has fallen out of favor and is usually reserved for special occasions or as a tourist attraction. This Norwegian family, however, habitually wear their country's national dress and, as a result, attract quite a lot of media attention. They were very happy to pose for the camcorder, and this allowed a detailed and well-composed group sequence to be shot (right), which was far better than the initial, rather stilted, opening sequence (below).

USEFUL TIPS

● If you are in a country where the customs may be unfamiliar, make sure that your recording does not cause offense. Be sensitive to the fact that people may object to being taped.

● If you suspect that you will not be able to buy your preferred brand of videotape at your vacation destination, ensure that you take sufficient spare tape for all your needs. This is a must in third-world countries.

103

▶ Architectural heritage

With architectural subjects, there is always the risk that, despite the beauty and interest the building may have, the video coverage leaves the audience thinking 'What's next?' A thoughtful approach, in which you spend a few minutes planning your shots, finding the best shooting angles, and rehearsing any camcorder movements, may largely circumvent this problem. With the subject here, the Leopoldo statue and murals in Salzburg, Austria, the building first comes into view at the end of a left-to-right pan shot from the other side of the street (frame 1). Next, there is a cut to a low-angle shot of the statue followed, after a slight change in shooting angle, by a detailed close-up of the horse (frames 2 and 3). This imagery is cleverly used to link the footage to the next shots, similarly framed close-ups of the painted murals (frames 4 and 5).

1

4

5

104

◀ Window displays

One of the pleasures of being on vacation is indulging in the local food specialities, so some shots of food displays might make an integral part of your videotape. Window displays are attractively arranged to catch the eye and tempt the taste buds of passersby, and what looks good to the eye makes a good subject for the camcorder.

3

▶ Street scenes

It is amazing how quickly one adapts to the sights and sounds of a new locale. Only a day or two after arrival, what at first seemed so strange and new begins to look commonplace and prosaic. The best advice is not to think that you can always come back at a later date to shoot a particular scene – when the opportunity presents itself, take it! The bright colors and fantastic patterns, textures, and designs of this outdoor market in Peru is an example of when to use this policy. The market is held only occasionally and there was just an empty square on the next trip through the town.

◀ Wait for the light

Good video coverage is dependent on the quality of the light falling on the subject. A badly exposed sequence will not be pleasant to watch and, as a record of your vacation, will be disappointing. The subject here, a statue of Mozart in Salzburg, Austria, initially was directly lit by strong afternoon sunlight. The glare off the gold was blinding. It would have been possible to close the lens iris down to expose the statue properly, but this would then have left the rest of the scene in near darkness. The solution was to spend an hour exploring the surrounding gardens, coming back every 15 minutes or so to see if the light was more favorable.

Beach barbecue

A gathering of family and friends for a day on the beach and an informal barbecue lunch is the ideal opportunity to shoot some video footage. Before recording any material, however, look through the camcorder's viewfinder to find the shooting angles that show both the people and the setting in their best relationship. Then, when you are sure that unattractive pile of litter or houses in the background will not appear in the shot, press the trigger and start recording.

▶ Opening sequence

Starting off in long shot helps to ensure that all the characters in the story can be seen, and establishes the location of the tape. Don't stay in long shot for too long, since detail will be lost on an average-sized television screen. This opening sequence moves quickly into a mid-shot of the lunch being unpacked, and a close-up of the barbecue itself underway.

1

2

106

▼ The right camera position

Assuming that you have thought your shooting angles through in advance, much of the taping can be done from a single camera position. In this sequence you can see that, apart from one close-up of the boy reacting directly to the camera, the camcorder was practically stationary throughout – there was enough movement and interaction between all the participants to maintain interest, making changes of camera position superfluous.

7

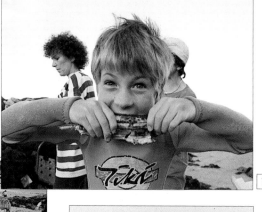

6

5

USEFUL TIPS

● Harsh sunlight and reflective sandy surfaces can create more contrast than videotape can comfortably handle. Therefore, choose a camera position that minimizes contrast if you think it may be a problem.

● Take basic precautions to protect your camcorder from the damaging combination of salt-water, which is corrosive, and sand and grit, which can abrade the glass lens and foul up the camcorder's internal mechanisms.

4

3

▼ Silence is golden

Try to keep as quiet as you can while taping. If you start shouting to distant subjects you will find it hard to keep the camcorder steady and your voice will drown out all the atmospheric noises.

10

9

8

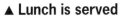

13

1

▲ Lunch is served

A series of mid-shots and close-ups of the food being cooked and eaten makes a suitable concluding sequence for this coverage of a barbecue – a tape that will take up only 2 to 3 minutes of screen time.

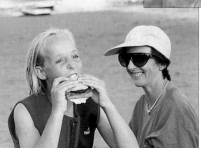

12

Children's games

Some of the best video coverage comes from catching people when they are unaware of the presence of the camcorder. Young children, in particular, are often at their most appealing when engrossed in an activity that really captures their imagination. The trick is to let them settle into their game or other activity before you start to record them. In this way, what they are doing will be more interesting to them than what you are doing and, with luck, they won't start playing up to the camcorder.

▶ The search is on

The opening shots in this coverage (frames 1 and 2), shows one of the children beginning an intensive search along the rocky shoreline. She knows what the hunt is for, but at the moment the audience has no idea. Don't hold a long shot like this for too long, since detail will be difficult to discern on a television screen.

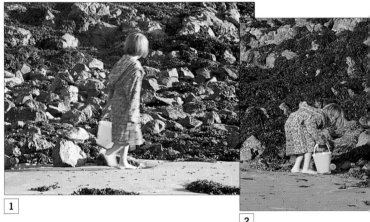

1

2

108

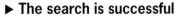

4

▲ Moving in closer

You need to judge the situation and move in closer when you feel you won't inter-rupt their activity. Here, both children are so involved in what they are doing that they pay scant attention to the cam-corder. By framing this sequence in a tight two-shot, it is possible to see the different expressions on their faces.

5

6

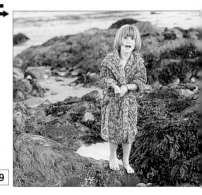

▶ The search is successful

Now that the little girl has captured her quarry, she wants to show it off and actively attracts your attention so that you can record it. Starting off in long shot (frame 9), it is easy to cut to a close-up of her closed hands (frame 10) and hold the framing as they open (frame 11) to reveal a tiny crab.

9

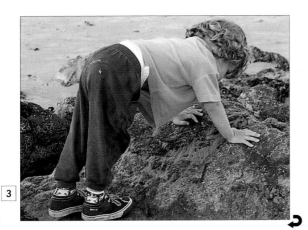

3

▲ Introducing another character

This cutaway (see pp. 54-55) is a mid-shot of the little girl's brother. He has seen her searching among the rocks and is scrambling down to join her. If planned for, this cutaway could be achieved using in-camera editing techniques (see pp. 62-63).

USEFUL TIPS

● Video coverage of children is almost always more successful if shot from their height, not from the normal standing position of an adult.

● When taking your camcorder on the beach, take basic precautions to protect it from flying sand and the corrosive effects of saltwater spray.

● If you plan your different sequences carefully before shooting, you will be able to cut from shot to shot without having to edit your material afterwards.

109

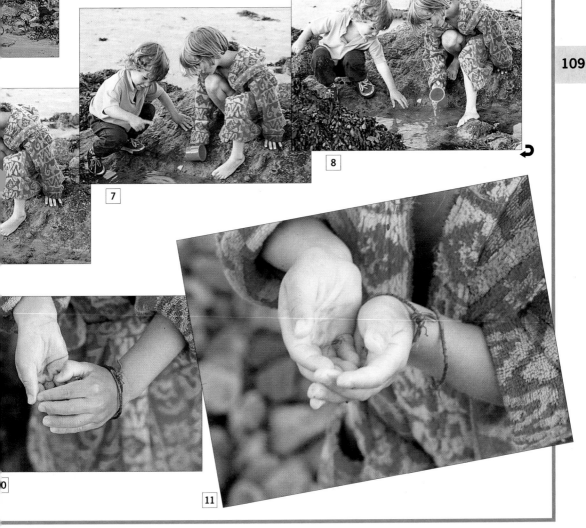

7

8

0

11

Unexpected events

When on vacation you will have more time to seek out likely subjects for the camcorder. Although it is important to get plenty of location footage and shots of your companions – members of the family or friends – your finished tape will be far more varied and enjoyable to watch if it contains as wide a range of subject matter as possible. In this regard, keep your eye out for any unusual or unexpected events that may occur during your vacation, such as this sequence of a mime performance.

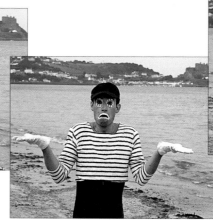

110

▲ Silence is golden

The humor of a mime depends largely on his or her ability to believably portray some perfectly ordinary and mundane event – such as pretending to carry a length of invisible wood or climbing an imaginary ladder – in complete silence. The full impact of the mime's act must be communicated through hand and body movements and, of course, facial expressions. When using a camcorder to tape an event like this, it is very easy to forget that the microphone will pick up any comments you might make, as well as those of people nearby. If these comments are relevant to the visuals, then it might not be too bad. However, the whole atmosphere could easily be ruined if the soundtrack consists of inconsequential chit-chat. Seeing that in this sequence the subject hardly moves from the same spot, it is best to fix the camcorder to a tripod and shoot the whole sequence with the subject positioned in the same area of the frame. This way, the audience can concentrate on the performance itself without the image wandering about all over the screen.

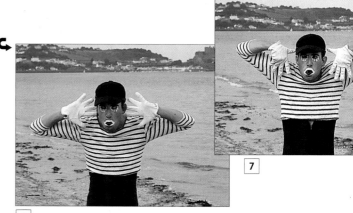

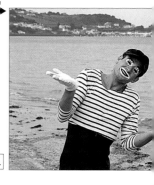

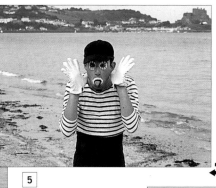

5

4

10

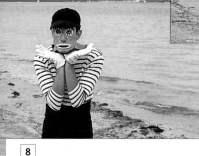

9

8

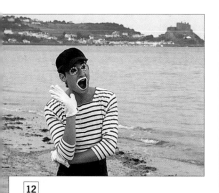

12

USEFUL TIPS

● Use the zoom lens to find the framing that shows the subject and setting to best advantage and then leave the zoom control alone. Zooming in or out while the tape is recording should occur only if the lens movement is justified by the screen action. You could, for example, slowly zoom in to a close-up of the mime's face once the act is over and you have the clapping of the audience there on the sound-track to justify it.

● Recording an event such as this will have more impact if the camcorder is completely stationary throughout. Best results will be achieved with the camcorder on a tripod. Once you have set the height of the legs and have the camcorder pointing in the right direction, with the lens at the best focal length, you only have to monitor the action through the viewfinder to ensure that the subject doesn't move out of the autofocus target area. If this should occur, then move the camcorder slowly and deliberately so that the subject is center frame once more. A rushed or jerky movement will look like an obvious mistake when seen on screen.

● A lightweight alternative to a tripod is a monopod. You can't achieve the same degree of steadiness with a mono-pod, however, but using one is better than trying to hand-hold a camcorder completely still for any length of time.

Organized events

A video of an organized event such as this flower festival requires a degree of planning if it is to tell a coherent story and be anything like comprehensive in its scope. As you can see, this tape begins with the flower beds belonging to the nursery staging the festival, before moving on to show the finishing touches being applied to the floats and exhibits, and only concludes with the public event itself. In fact, the first two locations are also open to the public, but you have to phone first for directions and times.

◀ Scene transition

An establishing shot sets the scene, and showing the flowers that the floats are decorated with gives extra background information. There is a strong sense of depth due to the apparent convergence of the sides of the flower beds. This helps to draw the audience into the shot and justifies the cut to a more detailed mid-shot and then a close-up. A dissolve is used to accomplish the transition from outdoors to indoors.

112

▲ Developing the story

Having moved inside at frame 4, it's important to have another establishing shot to reorientate the audience. These wide shots show the flower arrangers, so allowing the next shots to concentrate on those same people intently at work. The close-up at frame 9 is a detail of the previous shot.

USEFUL TIPS

● If your camcorder does not have an automatic white balance control, remember to set the white balance manually when moving from a sunlit scene into one illuminated predominantly by artificial light.

● Varying your shooting angle for different shots provides additional interest, as does varying the length of the individual shots making up a piece of the action. Quick cuts between shots imparts a sense of excitement and drama to your coverage.

6

5

113

12

Coordinated imagery

series of mid-shots has been taped how a coordinated selection of ts with an animal theme. A variety of era angles gives additional interest.

11

13

14

▲ Linking imagery

In order to create a near-seamless transition from the warehouse where the flower floats were being constructed to the assembly point outside, the final inside shot (frame 13) shows a crown, while the first outside shot (frame 14) shows a similar crown in close-up. As the lens zooms out slightly (frame 15) to increase its angle of view, the change of location become obvious as the sky and enormous tulips come into sight. The difference in shot sizes (see pp. 34-35) between frames 13 and 14 prevents an error known as a jump cut (see Useful Tips, opposite).

114

17

10

18

USEFUL TIPS

● If you don't plan to edit your tape afterwards (*see pp. 154-55*), you will need to plan your shots carefully to avoid jump cuts. These are two consecutive shots of the same, or a similar, subject showing very little difference in shot size. It nearly always looks like an error – as if the action has somehow jumped from one image to the next with an intervening shot cut out of the sequence. If you do intend to edit, you can disguise the jump by inserting a cutaway between the shots.

● If the action making up your tape is taking place in more than one location, make sure you know the routes between them and that you leave plenty of time to get set up in the best camera position at the next one.

● If the streets where you will be taping are crowded, try to find an elevated position to work from. Shooting over the heads of spectators all the time makes it difficult to vary the camera angle, but it is preferable to having the lens blocked or the camcorder joggled.

◄ Pan and zoom

The cut between the crown and the buck-toothed rabbit (frames 15 and 16) has a certain subtlety mainly due to the repetition of the deep pink and yellow color scheme. In general, a zoom should not normally form part of the tape itself (see pp. 44-45), but rather it should be used to set the appropriate lens framing before starting to record. Here, however, a zoom has been used effectively to allow more detail to be seen in the jungle tableau featuring a monkey and parrot. Frame 17 shows the whole float, while in frame 18 you can see the effect of a zoom in coupled with a slight pan to adjust framing to keep the monkey and parrot attractively centered.

◄ Exercise discretion

The temptation, especially if time is limited, is to cram as many different shots into your coverage as possible. Quality is always better than quantity, however, so be discriminating about what you record. Take whatever time is available to find the most telling camera position and frame the subject attractively in the viewfinder without the tape running, and only start recording when you are completely satisfied.

116

23

26

◄ Camcorder position

The streets on the route of the festival procession were closed to
traffic an hour before the floats were to arrive, so it was vital to
leave the assembly point in plenty of time to park the car and find
the best shooting position. It would have been ideal to have had a
mixture of coverage from street level and from a higher vantage
point, but you have to accept the limitations imposed by shooting
with only one camcorder. A local video club was also making a tape
that day – they had 12 camcorders to ensure complete coverage.

City vacations

Taking a city vacation will give you an opportunity to try out many different video techniques. In the midst of a busy, complex environment like a modern city you should find scores of subjects to tape – not only people at work and play but also different styles of architecture, modes of transportation, parks, rivers, canals, tourist spots, and restaurants. And with everybody about you busily concerned with their own affairs, you should find plenty of chances for candid footage.

▶ Historic sites

Every city has its fair share of important historic buildings. The sequence shown here is of the Imperial Palace in Vienna, Austria. To orient your audience, a wide-angle shot is always useful (frame 1). For close-up views of the intricate details the building has to offer, you can then zoom in, correct the framing in the viewfinder, and start taping again (frames 2 and 3).

1

2

118

1

▲ City color

The color and atmosphere of a city depend as much on the ordinary, everyday sights and sounds as they do on the more grand and historic aspects. This sequence of images was shot in an outdoor market where the Viennese come to buy their fruit and vegetables. The opening shot, taken as a mid- to long shot, has real impact due to the cacophony of colors of the different types of produce laid out to tempt passing customers.

3

2

USEFUL TIPS

● If you are going to be out all day and will not have easy access to your hotel, make sure that you have plenty of spare, fully charged batteries with you, as well as blank video-cassettes.

● To avoid an overlong tape, which may need to be edited afterwards to make a lively screening (*see pp. 154-55*), don't shoot more than will make a positive and interesting contribution – often just a few seconds of each sequence.

● Due to the close proximity of tall buildings blocking, partially or completely, the available sunlight, lighting quality in city locations can vary enormously over relatively short distances. Before committing a shot to tape, evaluate the available light and, if it is not right, try to find a more revealing or flattering shooting angle.

3

4

5

1

▲ Church architecture

This opening shot, of the Am Steinhof church in Vienna, is particularly dramatic due to the shooting angle. The interior of the church proved to be as rewarding as the outside in terms of video coverage, and the stained-glass windows seem to shine out of the shadows. Although most modern camcorders respond automatically, with older models you may need to reset the white-balance control if the interior is predominantly lit by tungsten.

2

3

1

2

▲ Local tourist attractions

One of the easiest ways of getting about in downtown Vienna is by using the extensive network of trams. If trams or trolley cars are a thing of the past where you come from, then they will have an obvious novelty value for your tape and so are well worth recording. Most of the tourist attractions in central Vienna are accessible from the trams, making shots such as those represented by frames 3 and 4 of this sequence very easy to achieve. Everybody is so used to tourists in places like this that somebody using a camcorder attracts not even a casual glance from passersby. As long as the exposure difference is not too great, including sunlit and shadowy areas in the scene helps to give your images extra visual interest (see pp. 30-31).

4

5

4

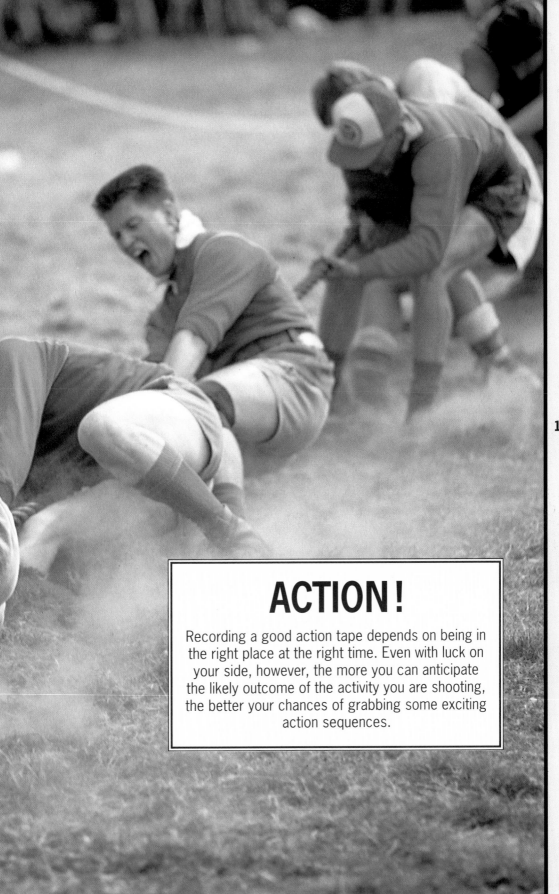

ACTION!

Recording a good action tape depends on being in the right place at the right time. Even with luck on your side, however, the more you can anticipate the likely outcome of the activity you are shooting, the better your chances of grabbing some exciting action sequences.

Keep the tape running

It is impossible to predict how any particular event or piece of action is going to turn out, and sometimes it is what happens after the action is over that contributes something positive to the overall coverage. You will involve yourself in no additional expense if you therefore keep the tape running a little longer to ensure you don't miss out on extra usable material. If it doesn't contribute anything, you can always play back through the viewfinder monitor and tape over unwanted footage with the next scene.

124

◀ First viewpoint

You should always try to add a touch of professionalism to your recording in order to make your tapes a real pleasure to watch. If you study television coverage of an athletic activity, such as the long jump, you will see that the same event is nearly always re-corded from more than one angle. Obviously this is impossible with only one camcorder – unless, that is, you cheat a little. For the first part of this coverage of a sports' day long jump, the camcorder was set up to show the competitor side on, sprinting down the track and taking off for his attempt at the record.

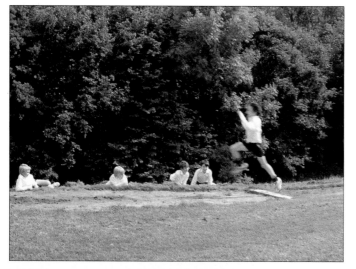

1

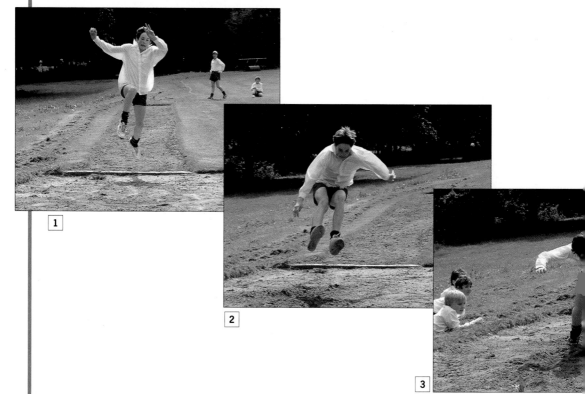

2

3

USEFUL TIPS

● One of the 'rules' of moviemaking that you can use to your advantage is that the audience will always perceive consecutive scenes as being part of the same event unless there is evidence to the contrary. In the example on these pages, it is reasonable for the audience to believe that the first and second shots are of the same jump.

● Subject movement toward you is not as testing for the autofocus as that across the frame, because the subject occupies the same area of the frame when moving toward the camcorder.

● When taping, don't cross the imaginary line along which your subject is moving – otherwise the direction of movement will appear to reverse (*see pp. 46-47*).

6

5

4

◄ Second viewpoint

This second part of the coverage of the long jump shows the same competitor now head on to the camcorder as he completes his take-off from the sprinting track and comes to land in the sand. Obviously the only way this two-part sequence could be achieved is by taping two jumps by the same competitor. Although it is a cheat, it makes for a far more entertaining tape. The temptation is then to pause or switch off the tape as soon as the competitor touches down and has come to rest. However, by keeping the tape running you may capture the look of dejection or elation on his face as he evaluates his performance and struggles to his feet and tries to regain his balance. Allowing the tape to run that little bit longer often helps to bring a sequence to a natural conclusion. If you stop taping before the event is completely over, you could end up with jerky scene transitions and your audience will be left with the feeling that something is missing.

Following the action

Exciting, dangerous sporting activities such as hang-gliding make excellent subjects for the camcorder. This is one of the few shooting examples when it is quite acceptable to zoom while actually recording, rather than using the zoom to set the framing before shooting. This is because your subject's movements will be extremely unpredictable and it is important to keep the subject as large as possible in the frame for most of the coverage.

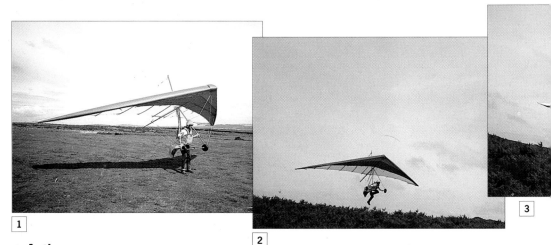

126

▲ Action sequence

The first frame in this sequence of shots shows the hang-glider readying himself before starting his run. These preparations may take a few minutes, so you should have plenty of time to get into position at the take-off point, which you can see in frame 2. The transition between frames 2 and 3 shows the hang-glider getting his legs into the supporting bag and, from then on, it's a matter of following his movement through the sky, trying all the while to keep camera and zoom movements to a minimum. Those movements that are necessary should be carried out as slowly and steadily as possible so that everything seems unhurried and planned in advance. If the hang-glider lands close by, you should also be able to record some footage of him looming larger and larger in the frame.

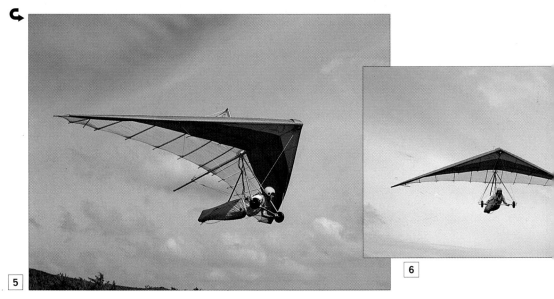

4

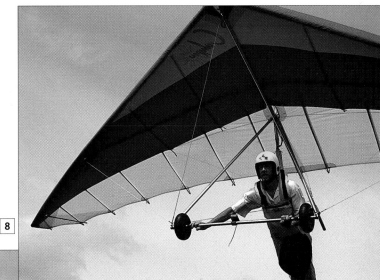

8

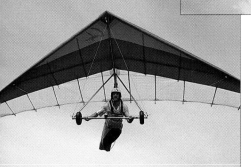

7

USEFUL TIPS

● Using a tripod will probably be too restrictive for a subject such as this, but make sure you adopt the right shooting stance for handåheld taping so that the camcorder is as steady as it possibly can be throughout (*see pp. 22-23*).

● Tracking the subject accurately with the camcorder is important in order to keep him roughly in the same area of the frame all of the time. If, however, you get a little ahead of or behind your subject, correct your mistake slowly and deliberately and then the error may pass unnoticed on screen.

● You will almost certainly need to use the zoom control while shooting this type of subject. Zoom the lens slowly and steadily and, if your framing is not perfect at the end of the zoom, then correct the error smoothly and deliberately.

● Taking the windscreen off your microphone will allow the sound of the wind to dominate the sound-track, which can add atmosphere to your tape.

Anticipate the action

Whether you are taping an international athletic meet or your child's annual sports' day activities, you will need to anticipate the action in order to get into the right camera position before the action occurs. Think beforehand of the types of shot that will make the most exciting and watchable five-minute tape.

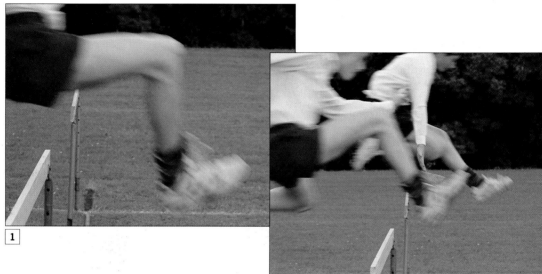

1

2

▼ Practice run

If your own child is one of the competitors, then you will want to ensure you get plenty of footage of him for family and friends, and of course the subject himself, to see afterwards. You won't necessarily be able to guarantee a clear shot while the real race is on, however, so take advantage of any less-fraught moments you get to tape him on the practice track. If you intend to edit your tape (see pp. 154-55) then you may be able to intercut between this material and real action shot during the actual race.

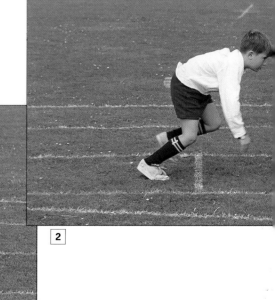

2

1

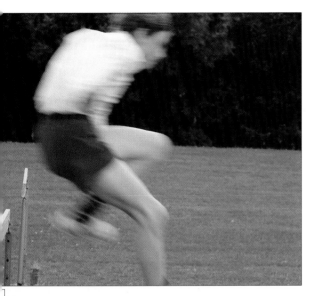

◄ Obstacles and hurdles

Where you position yourself depends on the type of race you are taping. For an obstacle course or, as here, a hurdles race, you are likely to see most action directly adjacent to the hurdles themselves, about halfway along the course. This is when the competitors should be into their stride and jumping fluently yet still sufficiently bunched together to fill the frame out with bodies. To anticipate the action, it is best to prefocus the lens on the hurdle you are covering. Don't rely on the autofocus to pick up the action – there is bound to be a second or two while it searches for the best position for a fast-moving subject, by which time you may have missed the shot completely. And keep the camcorder as still as possible – the runners will be streaming past your position so there is no need to pan or follow focus.

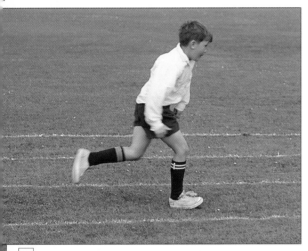

▼ The vital moment

The finish line of any race is where you are likely to record the most emotional moments as the winning competitor breaks through the tape. If you keep the subject in the target area of the viewfinder throughout, the auto-focus should have no problems adjusting the lens as the runner approaches your position. You may have to zoom back slightly, however, as the figure grows larger and larger if he or she is likely to 'overfill' the frame. Keep this zoom movement slow and steady.

129

3

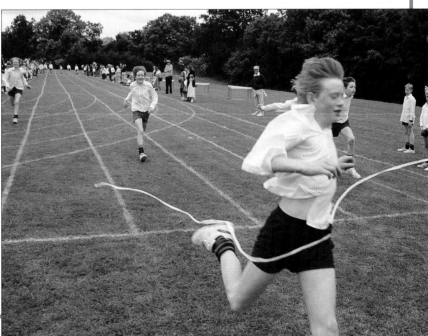

Choosing a shooting position

The successful coverage of an action subject such as this tug of war depends almost entirely on you choosing the right camcorder position from the outset (*see also pp. 128-29*). In an informal event such as this you will have a certain degree of freedom to move about on the periphery of the action, but you will need to take care not to get so involved in the shooting that you end up obstructing the action itself! Keep a safe distance away, but not so far that you can't anticipate the unfolding action. You won't necessarily want to use too long a lens setting because of its shallow depth of field.

▼ Guessing the outcome

A tug of war rarely lasts longer than a few minutes, so try to evaluate the relative strengths of the teams and choose a camcorder position to favor the winning side. Before the event got under way, this team looked to be the stronger. The very oblique shooting angle, with the lens set to wide-angle, gives ample depth of field, but you then have to be close to the action.

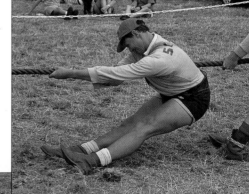

2

1

▶ Conclusion

As the contest progressed toward a conclusion, it became obvious that this team was beginning to weaken. A quick change of camcorder position allowed a pan along the line of desperately straining figures, finishing on the team's anchor man, his boots digging into the ground for purchase, but to no avail.

8

7

▶ Showing the other team

Your coverage can't be one sided or the activity will not make sense on screen. This second sequence, of the opposing team, shows them gaining the upper hand. Zooming in to a mid-shot brings up the detail sufficiently for you to be able to see the knotted muscles and pained expressions of the participants.

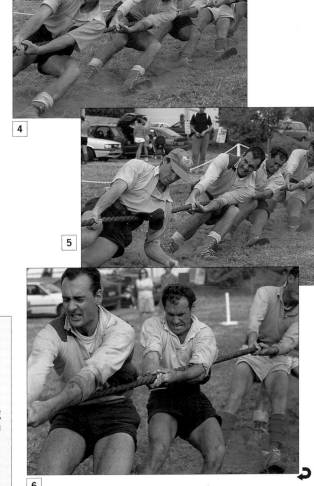

4

5

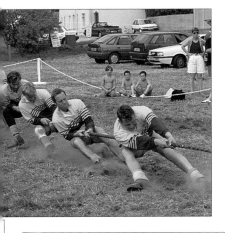

USEFUL TIPS

● If time allows, try for close-ups of the participants' faces to show the effort and strain of the activity.

● Reaction cutaways of the watching crowd help to make a more entertaining tape. If necessary, you can edit these in afterwards (see pp. 154-55).

● Remember that pausing the camcorder will cause a break in the continuity of the soundtrack. Plan cuts where they won't affect the sound too badly.

6

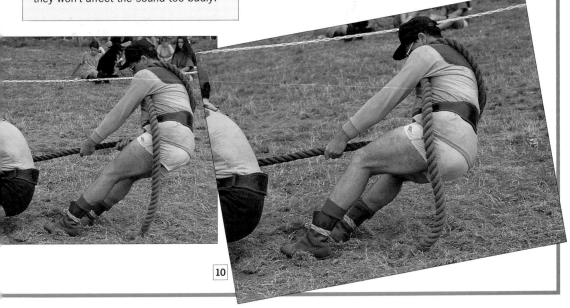

10

Fixed camera position

At many types of organized event, you simply do not have the option to wander about freely with your camcorder. At a football game, for example, you will usually have to shoot all your footage from your seat in the stands. In the example illustrated here, at a racetrack, the best advice is to find that part of the track where you are likeliest to see the most exciting action, such as on a difficult curve. Set the camcorder up where it has an unobscured view and let the action come to you.

▶ A good vantage point

This excellent sequence of images was shot from a fixed camera position on a slightly elevated piece of ground adjacent to one of the trickiest bends this racetrack had to offer. The high ground ensured an uninterrupted view of the speeding cars and the lighting contrast added 'crispness' to the images.

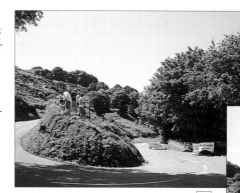

▼ Look for details

Other types of cutaway you can insert at relevant points in your tape include this detail of a twisted piece of door panel from one of the cars that didn't finish the race.

▲ Reaction cutaways

No matter how good your fixed vantage point is, it is always best to include other types of footage on your finished tape to give variety and a more rounded impression of the day's events. A professional touch would be to shoot some reaction cutaways, which you could edit into the tape afterwards (see pp. 154-55). Taking the sequence at the top of the page as an example, you could insert somewhere in the middle of it this shot of the crowd reacting to the car screeching around the bend. In fact, the crowd shot could be taped from an entirely different part of the track – assuming there was nothing to give the ruse away – and nobody would be any the wiser.

132

USEFUL TIPS

● A fixed shooting position doesn't necessarily mean a stationary camcorder. Moving just a few feet to the left or right, squatting down, or standing on your seat can help inject variety into your sequences.

● The more you know about the activity or event you are taping, the better your chances will be of anticipating where the most exciting action may occur. If you are unsure, take note of where the crowd is most dense.

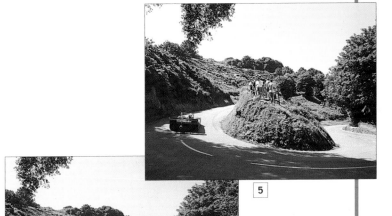

5

4

▼ Movie montage

At the end of a day's shoot, you are likely to have numerous sequences that didn't come off properly for one reason or another. Perhaps you didn't pan well enough through the shot, or somebody walked in front of the lens partway through a shot. Why not edit together the best bits of these shots to make a movie montage of the day's activities?

133

3

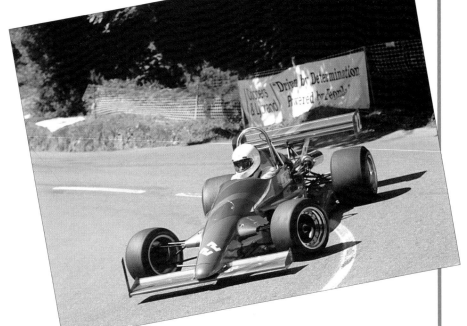

Spontaneous action

You never know when a good action sequence may occur, so the best advice is to keep the camcorder running and, if necessary edit the tape afterwards (*see pp. 154-55*). To avoid too much wasted material, however, you need to remain alert to the way situations around you are developing, and if children are your subjects expect the unexpected to happen. Choose a shooting position that gives you an uninterrupted view of the scene and where the light shows the subjects most favorably.

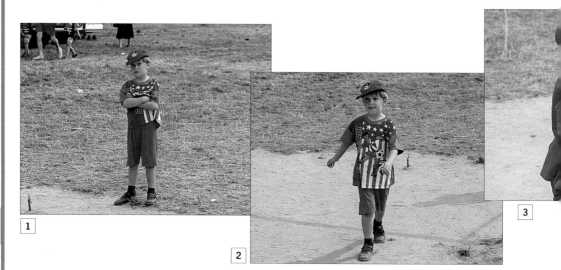

134

▲ Keeping alert to your surroundings

I noticed this young boy standing on the sidelines watching some boys he didn't know playing soccer. He was obviously very anxious to join in, and was becoming more and more excited, but could not overcome his shyness. Nevertheless, I thought it might be worth recording him to see what developed (frames 1-4). After a few minutes he couldn't hold back any longer and called out to the boy in red to ask if he could play (frame 5). Then, with total

disregard for the etiquette of the game, he took the ball away from his new teammate (frames 6-7), who was in a goal-scoring position, and kicked it into the net himself (frame 8). For the final shot (frame 9) I changed camera position slightly.

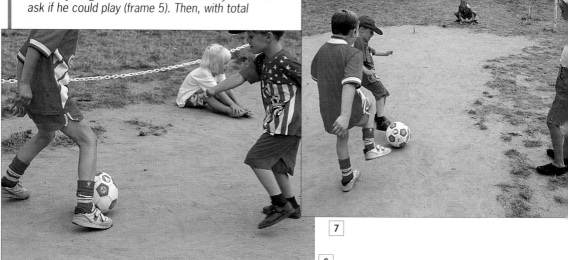

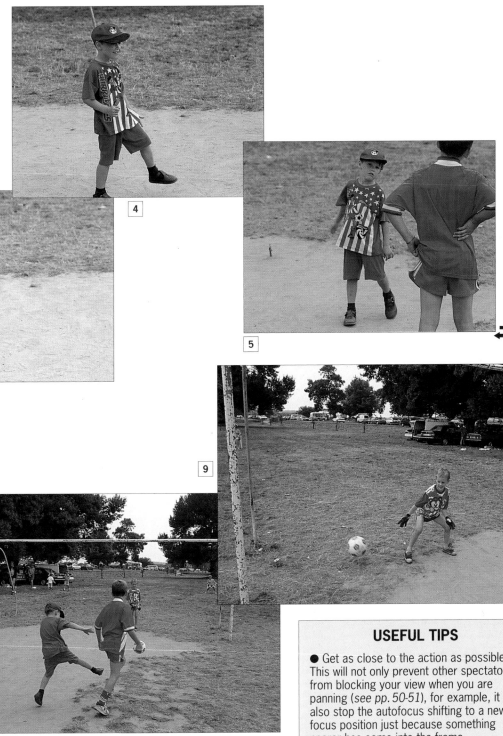

4

5

↪

135

9

8

USEFUL TIPS

● Get as close to the action as possible. This will not only prevent other spectators from blocking your view when you are panning (*see pp. 50-51*), for example, it will also stop the autofocus shifting to a new focus position just because something nearer has come into the frame.

● If you can't find an unobstructed position on the sidelines for the camcorder, then try to find a slightly elevated position further back that will allow you to shoot over the heads of the other spectators.

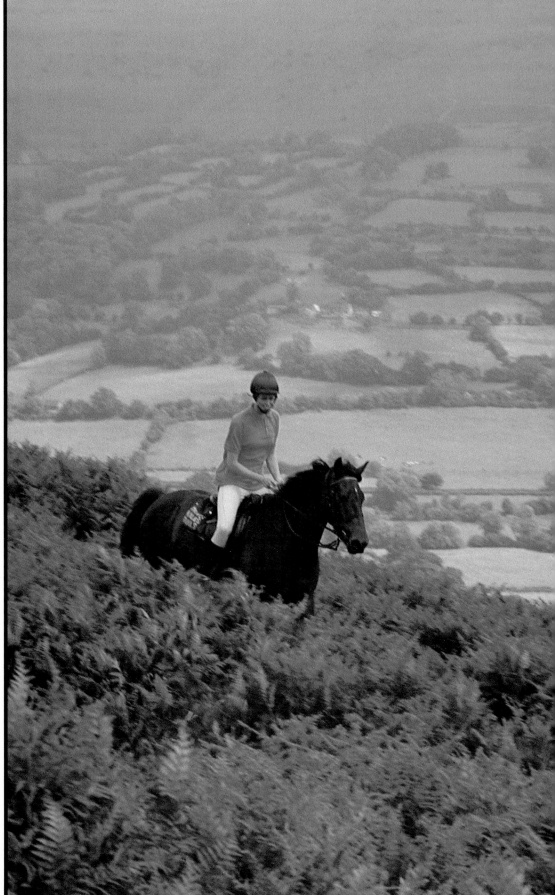

NATURAL WORLD

The subject area of the natural world is potentially very broad, taking in such topics as the many different types of landscape as well as the more cultivated surroundings of suburban gardens and flower nurseries. Also included here is the type of wildlife found at zoos and safari parks.

Landscapes

Many factors go to make effective landscape sequences. Having found the scene of your choice, next consider the light, which can be very variable – not only from minute to minute but also from season to season. The shooting angle is another critical aspect, as is the position of the horizon – down in the frame to emphasize the sky, or up to allow the land to dominate (*see pp. 36-37*). But it is often the inclusion of something familiar, such as a person, that helps to bring a sequence to life.

▼ Panoramas

To encompass a panoramic scene you will probably need to pan (see pp. 50-51). Before you start, look through the viewfinder and zoom the lens in and out until you find the focal length that gives the best overall framing. Next, look for an interesting feature to begin the pan, and another to end on – this will make for a more powerful sequence. Finally, rehearse the pan a few times before you tape so that your movements are fluid and the panning speed is just right.

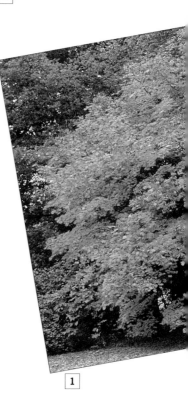

2

1

1

138

USEFUL TIPS

● Any type of camcorder movement, such as panning, is likely to be steadier and more professional looking if you use a tripod with a good-quality pan-and-tilt head (*see pp. 16-17*). If this is not feasible, then make sure you adopt the best possible shooting stance (*see pp. 22-23*). Keep your feet still throughout the movement and pivot your body from the waist.

● Since so many factors are beyond your control, shooting good landscapes sequences requires much patience. It may be better to wait for the light to change or for the clouds to move into the right position rather than to record the scene as you first see it.

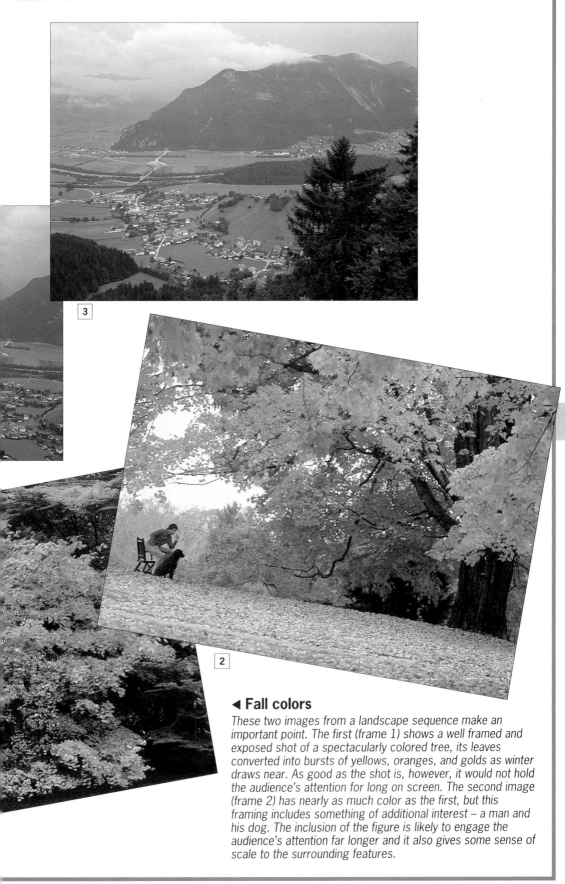

3

2

◄ Fall colors

These two images from a landscape sequence make an important point. The first (frame 1) shows a well framed and exposed shot of a spectacularly colored tree, its leaves converted into bursts of yellows, oranges, and golds as winter draws near. As good as the shot is, however, it would not hold the audience's attention for long on screen. The second image (frame 2) has nearly as much color as the first, but this framing includes something of additional interest – a man and his dog. The inclusion of the figure is likely to engage the audience's attention far longer and it also gives some sense of scale to the surrounding features.

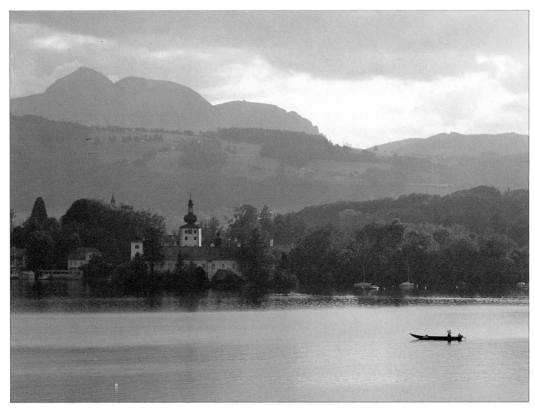

▲ Depth and distance

Distant views of even the most attractive country-side can look two dimensional if the foreground is empty and featureless. In the scene above, the small boat cutting across the still foreground water gives a sense of depth and distance: we know how big a boat is and, thus, can use this knowledge to judge distances and sizes in the rest of the scene.

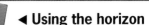

◄ Using the horizon

The video medium is ideal for recording the ways the natural landscape can change in both mood and character. The symmetry of the high ground sloping down on both sides of the lake dictated the initial framing of this sequence of images. However, it was the developing storm that determined the position of the horizon throughout. By placing the horizon low in the frame, additional emphasis is automatically assigned to the sky and the dramatically rapid buildup of clouds being drawn down into the valley.

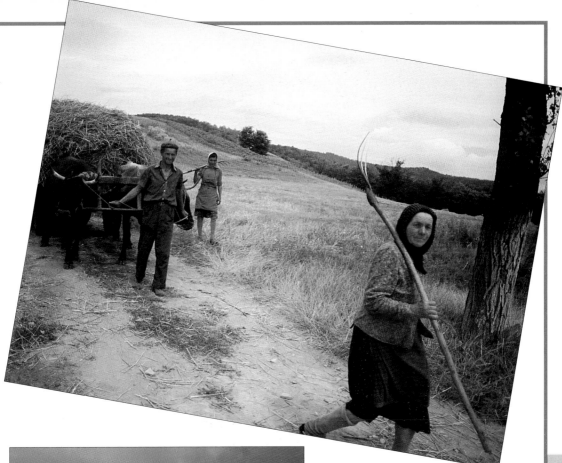

▲ The hand of man

Although it sounds like a contradiction, the most entertaining sequences of the natural world are often those in which the hand of man is somehow evident. In the first image in the examples here (above), shot in Romania, the camcorder was set up so that, initially, all that could be seen was an expanse of fertile farmland. After a few seconds, however, the soundtrack began to register the noise of an approaching ox-cart and farm workers talking to each other – long before they actually came into view. In the twilight image, taken in rural England (left), the winding country road and the moving tracks of the car head-lights traveling along it bring additional interest to the scene, engaging and then holding the interest of the audience far longer than if the camcorder had been shifted to the left to exclude the road completely. The hot, arid conditions of the Moroccan interior (bottom left) have an im-mediacy and realism simply because we can see how those living there have adapted their modes of dress and trans-portation to cope with them. The inclusion of the people and their donkeys brings home to the audience the harshness of the environment in a way that a peopleless scene could never convey.

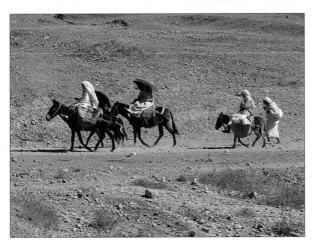

Gardens

Gardens make fascinating subjects for the camcorder. One of their chief visual assets is that they work well in long shot, when you can see the overall garden design, and in both mid-shot and close-up, when you can see intricate details and color to the exclusion of all else. Gardens also change throughout the year, making them very different subjects as the seasons progress. The three gardens featured below and on pages 144-47 were the three prize winners in a garden competition.

▲ Gold-medal winner

This sequence of images is of the prize-winning garden on the island of Jersey, off the coast of England. This short sequence starts traditionally, with an establishing wide shot showing a riot of color, before cutting to the gardener himself. Different framings of the gardener were achieved by walking around him with the camcorder running. This introduced various aspects of the plants before cutting to a close-up at frame 6. The rest of the images are taken from a slow, continuous pan along one of the densely planted flower beds.

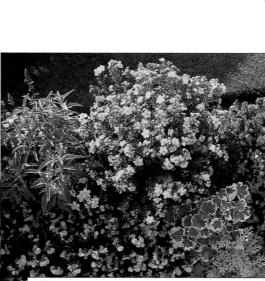

4

5

9

1

2

3

▲ Silver-medal winner

This garden came second in the Jersey garden competition. When planning your coverage, keep alert to shots that could be used for opening credits. In this example, the sequence opens with a neatly framed close-up of a basket of flowers set against evenly patterned gravel, which could form the perfect backdrop on which to show the name of the gardener and the garden's location. After this opening scene we cut to an establishing wide shot showing more of the garden layout and then a slight change in camera angle is used to cover the introduction of the gardener himself. Frame 5 has been carefully composed so that many of the flowers that can be seen in the following close-up are featured. The rest of the coverage is a pan along the flower beds, with the view opening up as dictated by the varying heights of the plants.

144

7

8

6

4

5

9

1

▲ Bronze-medal winner

*In these images you can see a very different
garden style, and the coverage has been changed
to suit the new circumstances. Whereas the pre-
vious two gardens were along traditional lines, here
great use has been made of freestanding pots of
flowers and a profusion of hanging baskets. Central
to this garden's success, however, are the hard
surfaces, such as the outside wall, the welcoming
arch that forms the opening shot, and, of course,
the house itself, which is featured throughout. It is
these surfaces that, at times, nearly disappear
under the mass of flower color and thus make the
display so impressive. In design terms, the
dominant feature of this garden is its ordered
symmetry, and to echo this theme the opening shot
has been composed in an equally symmetrical
fashion. The arch, too, is very inviting, drawing you
naturally through into the garden proper. Here we
stay with the gardener longer than before, taping
while he waters and tends his floral creation.*

2

146

5

4

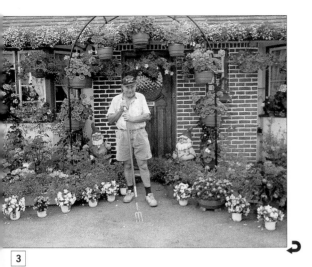

3

● Every garden has a different aspect in relation to the sun and, so, looks best at different times of the day. Although light is usually at its most intense at about midday, this is when contrast – the difference between bright highlights and deep shadows – is most extreme, making it not generally the best time for videotaping (*see pp. 24-24 and 30-31*). Instead, try shooting early in the morning or late in the afternoon. At these times of day, the softer, directional light tends to reveal more form and texture.

● Before starting to shoot, walk around the garden to find out what it has to offer. Take a few notes as you go and plan your coverage in advance. In this way you will either be able to produce a tape that doesn't require any editing at all (*see pp. 62-63*) or one that needs only minimal postproduction editing (*see pp. 154-55*).

● Bear in mind that gardens are often planned to look their best from particular vantage points – through a foreground arch, for example. Others, however, may reveal new aspects of their design if shot from above – perhaps from an upstairs window of the house.

● Rather than abruptly cutting from shot to shot, try introducing a few fades so that one flower is gradually replaced by another on screen.

147

6

Flowers

One way of making a videotape of static subjects such as flowers is to put together a series of carefully composed shots of the individual blooms or clusters of flower heads. The orchids featured here are not large, so the camcorder lens was either fully extended to its longest telephoto setting or set to 'macro' mode. Macro mode is commonly found on modern camcorders, and allows you to set the lens at a focusing distance much closer than the normal zoom range would permit.

▶ Introducing the subject

For a tape dealing with a special-ized subject, such as this for an orchid foundation, a good way of introducing the visual material is to start with a shot of the name of the organization itself. Next follows a series of carefully planned shots of one of the cluster-headed orchid specimens. Although the differences in vantage point between these initial shots is not great, we can see the flowers in such detail that each is significant.

1

◀ Exploiting depth of field

With the camcorder lens extended toward the telephoto end of its zoom range, you know that depth of field – the area of sharp focus around the point of true focus – is going to be limited. In many recording situations this would be a problem, since you often want the image sharp from foreground to background. Here, however, shallow depth of field works in your favor. In these three shots of different orchids, the blooms are sharp but the backgrounds have been reduced to soft, out-of-focus blurs that act as colored backdrops for the subjects without competing too heavily for the viewer's attention.

4

3

2

USEFUL TIPS

● Shot transitions achieved by fades rather than abrupt cuts may better suit this type of stationary subject (*see also pp. 142-47*).

● If you have an audio-dub feature, the soundtrack for a videotape on orchids could feature a factual, informative voice-over giving details of species names, habitat, and so on, or it could be composed of an appropriate piece of music.

● Rehearse all camcorder movements before committing them to tape.

▲ Macro mode

For a large close-up of a small subject, the zoom range is not sufficient. Instead, you need to set the lens to macro. Once in macro, the lens will focus on a subject much closer than normal. However, depth of field is then extremely shallow and any accidental camcorder movement would spoil the shot. This makes a tripod essential.

▶ Exploiting contrast

Although contrast within the subject is often a problem with videotape (see pp. 30-31), in some situations it can work to your advantage. In this shot, directional light was falling on the delicate cream-colored petals of the orchids, but not really penetrating to the ground beneath them. This created sufficient exposure difference between the subject and its surroundings to show them against a predominantly dark and featureless background.

Wildlife and zoo animals

Zoos, safari parks, and animal reserves, provide a limitless source of wildlife subjects for the camcorder. Unless you are really taping in the wild, however, you will need to choose a shooting position that shows your animal subjects in an environment that is as natural as possible. Before recording, check your viewfinder carefully to make sure there are no cars, fences, trash cans, corners of billboards, or similar distracting elements creeping into the edges of the frame.

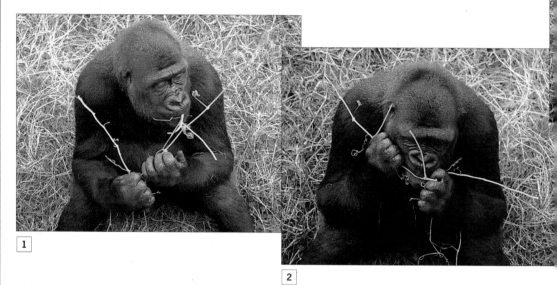

1

2

150

▶ Coping with wire

One of the main problems of trying to videotape birds or other animals in a zoo is that you will often be confronted by a wire-netting barrier between you and your subjects. If the gaps in the wire netting are large enough, then carefully fit your lens through before taping. If this is not possible, zoom in to the longest lens setting and position the lens as close as possible to the wire. This way, the limited depth of field – or zone of sharp focus around the subject – associated with telephoto settings will be so shallow that the wire will disappear in an out-of-focus blur. Overall, however, footage shot in this way will seem a little soft when played back.

1

2

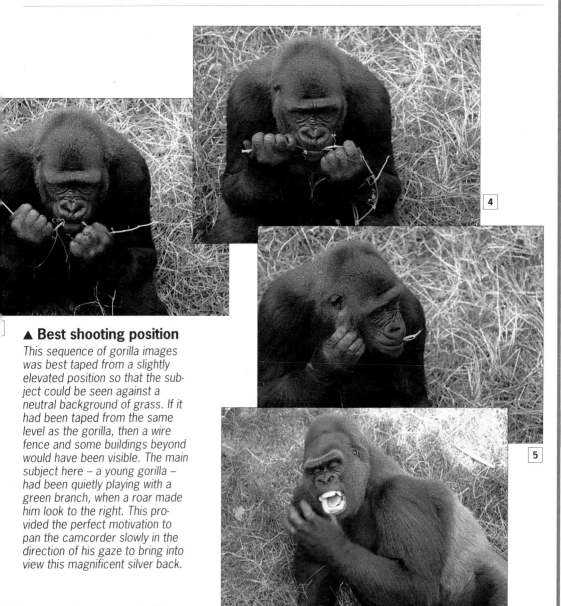

▲ Best shooting position

This sequence of gorilla images was best taped from a slightly elevated position so that the subject could be seen against a neutral background of grass. If it had been taped from the same level as the gorilla, then a wire fence and some buildings beyond would have been visible. The main subject here – a young gorilla – had been quietly playing with a green branch, when a roar made him look to the right. This provided the perfect motivation to pan the camcorder slowly in the direction of his gaze to bring into view this magnificent silver back.

151

USEFUL TIPS

● If you want to avoid excessive contrast, choose a camcorder position that shows both your subject and its visible surroundings evenly lit. Around noon on a sunny day is often the worst time to record a video because then the light is at its most contrasty.

● In order to record animal noises – when using the longest lens setting for distant subjects, for example – it is best to use a directional shotgun microphone rather than the camcorder's built-in microphone.

● Feeding time is a good chance for you to get action footage of animals. Find out the feeding times in advance so that you can select the best shooting angle.

▼ Zooming to good effect

Although zoom movements should not normally be a part of the recorded tape, in situations like this you can, in fact, zoom the lens to very good effect. For the opening shot of this sequence, the lens was already zoomed back to its widest setting to show the flamingos in their attractive lake and woodland setting. After holding this shot for about 7 seconds, the lens was zoomed slowly in, taking about another 7 seconds, to its longest setting in order to frame the flamingos as large as possible in the camcorder's viewfinder.

2

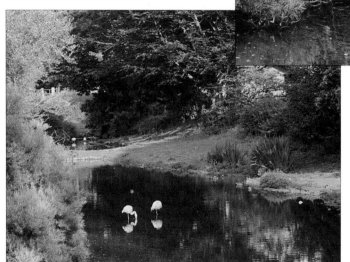

1

2

▶ Bright backgrounds

The framing here was governed by the fact that the bear's enclosure was surrounded by buildings, other animal pens, paths, and roads. So the best way to record his antics was to shoot from the lowest observation platform upward to frame him against the sky. However, this caused the lens iris to close down slightly and so the bear appears a little underexposed. It would have been possible to use the backlight-compensation control, but this would have caused the large area of sky to be overexposed, which would have been worse in this particular situation because there was so much of it.

1

3

153

4

5

Cuts-only editing

Editing the raw footage from your camcorder allows you to 'tidy up' the content of your tapes and so make them generally more enjoyable and watchable. It also gives you the opportunity to rearrange the order of scenes you have shot, for example, or shorten overlong coverage by, perhaps, omitting some scenes altogether or condensing others. Editing also allows you to introduce some of the tricks of the trade, such as cutaways, to help give your program a touch of professionalism.

HOW TO EDIT

The assumption in the following information is that you are using a basic editing technique in which your camcorder is the 'source' machine and a VCR is the 'record' machine.

1 The first stage of any edit is to review your raw footage in order to create an edit-decision list. Decide which scenes you want, which order they will appear in, and how long each will be. Use the tape counter and note the start and end points of all the material you want.

2 Check your instruction manual to see how to connect the camcorder to a VCR. This is usually achieved by using audiovisual (AV) cables. If you also connect the VCR to a television, you will be able to monitor the images as they are being recorded.

3 Place a blank cassette in the VCR. Set the controls of the camcorder – which has the master tape wound to the start point of the first scene you want – to play/pause, and the controls of the VCR to record/pause.

4 Release the two pause controls at *precisely the same time*. This will start the process of transferring your selected material from the camcorder to the VCR. Press both stop buttons at the point you have predetermined on your edit-decision list.

5 Review the scene you have just recorded onto the VCR to make sure it is correct. Find the start point of the next scene you want to transfer from the camcorder, and make sure that the tape in the VCR is at the end of the last scene you have transferred. Set the controls on both machines as described in step **3** above.

6 Continue in this way until you have transferred all the material you want from the camcorder to the VCR. Bear in mind that nearly all modern VCRs roll the tape back to cover the joins between edited material. This 'preroll' time varies widely between VCRs, and may require considerable effort from you to avoid unwanted frames being recorded.

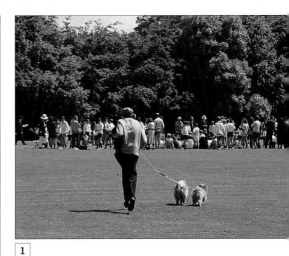

1

▲ Capturing the mood

Not every event is best portrayed by blow-by-blow coverage. Sometimes, mood can be more successfully conveyed with an edited compilation tape. The opening frame here (frame 1) shows a man hurrying to catch part of the hurdles race (frame 2). This is followed by mid-shot and close-up cutaways (frames 3 and 4) of different spectators. Next (frame 5), we see a close-up of an athlete's face, the finish of another race (frame 6), and, finally, a long shot of the trophies (frame 7).

4

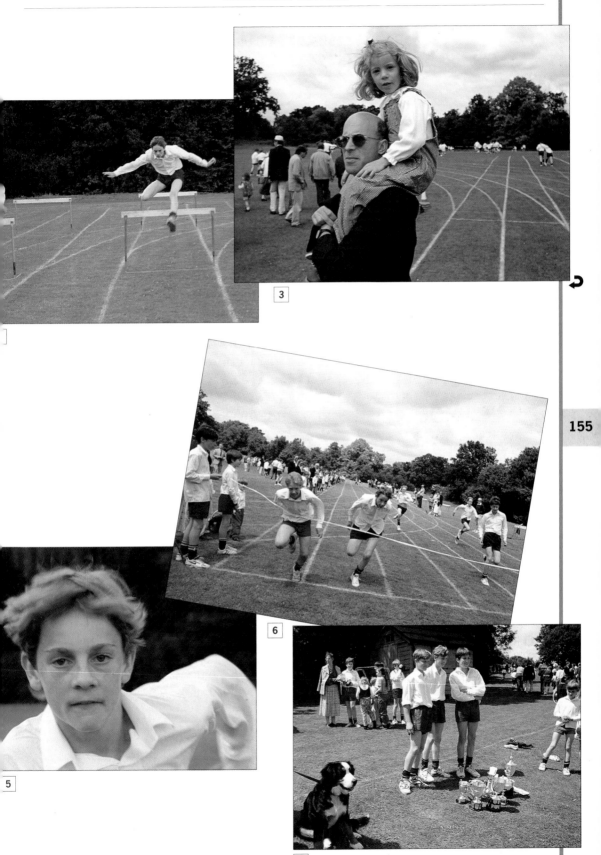

Glossary

(See also pp. 18-19 for further definitions of certain camcorder features.)

AGC Abbreviation for *automatic gain control*. Modern camcorders have separate AGCs to control both sound and exposure levels (*see pp. 18-19*).

Aperture A hole of variable size created by adjusting the iris, a set of overlapping blades within the camcorder lens. It is the aperture that controls the amount of light passing through the lens and reaching the charge-coupled device (CCD).

Assemble edit Copying shots from the source tape (recorded in the camcorder) onto a blank tape (the edit master) in the required sequence.

Audio dub Replacing the soundtrack on the videotape made at the time of the original recording with a new one consisting of a spoken commentary, music, sound effects, or whatever is appropriate.

Available light The light that is naturally present in a scene, indoors or outdoors. This may include daylight and ordinary room lighting, but not that added specifically for the purpose of taping.

Background soundtrack The ambient noises – voices, music, traffic noise, and so on – recorded at the time of taping.

Backlighting A lighting situation in which the subject is positioned between the principal light source and the camcorder. When this occurs, the side of the subject facing the lens may be substantially darker than its surroundings, leading to the subject being underexposed. In extreme cases, a backlit subject may be recorded on tape as nothing more than a silhouette.

Backlighting-compensation button A manual control found on most camcorders that allows more light to enter through the lens to compensate for backlit subjects.

Barn doors A clip-on or slide-in lighting accessory consisting of four hinged, square flaps. These can be moved independently backward and forward to control the spread of light from a videographic light source.

Boom A pole used to position a microphone near the sound sound source but out of sight of the camcorder. A lighting boom is used in the same way to position a light near the subject being taped.

CCD Abbreviation for *charge-coupled device*. A microelectronic chip, situated behind the lens of a camcorder, that converts light into electrical signals (*see pp. 18-19*).

Close-up A type of shot size, often abbreviated to CU, in which only the head and shoulders of the subject can be seen. With other types of subject, a close-up refers to any frame-filling detail.

Continuity The consistency of detail from shot to shot. This includes such things as objects and their placement, as well as light levels and sound (*see pp. 60-61*).

Cut The abrupt transition from one scene to another, achieved in the camcorder or as part of the editing process after taping is finished.

Depth of field The zone of acceptably sharp focus surrounding the actual point of true focus. This zone of sharpness varies, becoming more extensive at smaller apertures and at shorter lens focal lengths.

Dissolve A transition from one scene to another brought about by one image gradually

replacing the next. Dissolves are used as an alternative to an abrupt cut.

Establishing shot The opening shot of a sequence, usually taken with the lens set to wide-angle, designed to show the audience where the action that follows is taking place.

Eyeline The direction in which a person is looking. If taping a conversation by cutting from face to face, one person looking left to right must be compensated for by the other looking right to left, otherwise they will appear to be looking away from each other.

Fade A transition between scenes, or at the conclusion of a tape, in which the image fades out to black, white, or, often, another color.

Iris diaphragm A set of overlapping blades that open or close to leave a variable-sized aperture in the center.

Jump cut An editing fault when the cut between scenes seems to imply that some part of the action has been accidentally omitted.

Key light The principal light source illuminating the subject. It is usually used in conjunction with a fill-in light and a backlight.

Long shot A type of shot size, often abbreviated to LS, in which the framing shows at least a full-length figure or a broad sweep of scenery. Long shots, like establishing shots, are often taken with the lens set to wide-angle.

Mid-shot A type of shot size, often abbreviated to MS, in which the framing shows the equivalent of a human figure from about the waistline upward.

Mixed lighting A scene illuminated by a mixture of different artificial sources, such as tungsten and fluorescent, or by natural daylight and artificial light.

Panning Pivoting the camcorder while taping to encompass a broad view or to keep a

moving subject in frame (*see pp. 50-51*). For a professional-looking result, it is best to practice the pan before taping, carefully noting the start and finish positions.

Reaction shot A shot, usually of people reacting, or apparently reacting, to the main action. It can be taped at the time in the right sequence, or afterwards and then edited in.

Snoot A lighting accessory in the shape of a tube or tapering cone used to produce a narrow beam of light.

Steadicam JR A handheld, hydraulic camcorder support that allows the user to shoot steady images while walking or even running up a staircase.

Storyboard A series of shot-by-shot drawings used to plan a scripted piece of action. It shows such details as framing, shooting angles, and lighting directions. A very informal storyboard could consist of a simple written list of potential shots used to help you produce a coherent sequence of images if you don't want to edit the tape afterwards.

157

Tracking Moving the camcorder while taping in order to keep up with a moving subject (*see pp. 52-53*). Tracking shots usually require a dolly – a tripod with wheels – or a Steadicam JR if images are to be steady and sharp.

VCR An abbreviation for videocassette recorder.

Voice-over A spoken commentary accompanying a video sequence, usually recorded after the tape is shot and used to replace the background soundtrack.

White balance A control, usually automatic, that allows the camcorder to record colors naturally in both daylight and artificial light. In tricky lighting conditions, such as mixed daylight and tungsten, the auto white balance may be fooled. If the camcorder allows, adjust the white balance manually in these situations.

Index

158

159

Acknowledgments

The author is grateful to the following individuals
and organizations for their generous help and assistance in the
production of this book:

The Austrian Tourist Board; the Blampied family and friends;
Roger Bristow; E A Bruesnel; Drusilla Calvert; Dolly, Robin, Ben,
and Henry Carter; James Church; Kerry Fox; Jonathan Hilton; Sarah
Hoggett; G Huelin; P Sam Jefferson; Phil Kay; Jason Loveless;
Jenny Mackintosh; E Minier; Davy Pickles; Steve Wellum;
Bure Valley Railway; Isle of Man Tourist Office; Jersey Hill
Climb; Jersey Pottery; Jersey Tourist Board; the Jersey
tug-of-war team; Jersey Zoo; Moorings Hotel, Gorey, Jersey;
the masters and boys of St Ronan's School; the organizers
of the Spalding Flower Festival; Swansons Hotel; Wolfgang
and Lieseri (Vienna); Eric Young Orchid Foundation.

For the loan of equipment:
Canon (UK) Ltd; Hitachi (UK) Ltd; JVC (UK) Ltd;
Panasonic Consumer Electronics (UK); Sennheiser (UK) Ltd;
Sharp Electronics (UK) Ltd; Sony (UK) Ltd;
and Vanguard/Guardforce (UK) Ltd.